TAKING

THE

LEAP

INTO

new media

TAKING

THE

LEAP

INTO new

media

by Stephanie A. Redman

NORTH LIGHT BOOKS
Cincinnati, Ohio
www.howdesign.com

Taking the Leap Into New Media. Copyright © 1999 by Stephanie A. Redman. Manufactured in China. All rights reserved. No part of this book may be reproduced in any form or by any electronic or mechanical means including information storage and retrieval systems without permission in writing from the publisher, except by a reviewer, who may quote brief passages in a review. Published by North Light Books, an imprint of F&W Publications, Inc., 1507 Dana Avenue, Cincinnati, Ohio 45207. (800) 289-0963. First edition.

Other fine North Light Books are available from your local bookstore, art supply store or direct from the publisher.

Visit our Web site at www.howdesign.com for information on more resources for graphic designers.

03 02 01 00 99 5 4 3 2 1

Library of Congress Cataloging-in-Publication Data
Redman, Stephanie.
 Taking the leap into new media / by Stephanie A. Redman
 p. cm.
 Includes index.
 ISBN 0-89134-953-7 (pbk. : alk. paper)
 1. Web sites—Design. 2. Graphic design (Typography) I. Title.
TK5105.888.R43 1999 99-17287
005.7'2—dc21 CIP

Editor: Poppy Evans
Production editor: Nicole R. Klungle
Interior designer: Cindy Beckmeyer
Cover designer: Stephanie A. Redman
Interior production artist: Jennifer J. Dailey
Production coordinator: Erin Boggs
The permissions on page 142 constitute an extension of this copyright page.

TAKING THE LEAP INTO new media

by Stephanie A. Redman

Dedication

I'd like to dedicate this book to my daughter, Grace, and my husband, Bill.

Acknowledgments

I'd like to thank all of the contributors and the designers who shared their thoughts and experiences. No one has enough time these days, and designers seem to have even less. Because of this, I am grateful that these designers somehow found the time to very generously contribute their experiences, thoughts and predictions to this book.

About the Author

Stephanie Redman is the principal in a Cincinnati-based design company. Formerly art director of promotions with F&W Publications, Inc., she has over fifteen years of experience in advertising, publication/book and promotions design. While at F&W, she art-directed and coordinated the team that produced the *HOW* magazine Web site.

Table of Contents

Introduction

What's so new about new media? Does it seem new because designers can bring motion and sound to their work? TV and video do that. Does it feel new because a designer can use a variety of fun programs to create projects right on their computers in their studios? Computers and cool programs have been around for years. So just what is it that makes new media seem so different?

The difference, according to the experienced print designers profiled in this book, is interactivity—giving life to designs by allowing audiences to participate in the transfer of information. As Neil Powell of Duffy Design puts it, a Web site design "almost becomes a living organism. It may never be completed or it can always change." Powell points out that some Web sites allow consumers not only to select, customize and buy a product, but also experience what it's like to use it. Developing these kinds of interactive experiences offers designers a new realm of creative possibilities. "They can actually sit inside the car, turn on the windshield wipers and hear the engines rev," says Powell, describing a site Duffy Design created for BMW. "That's pretty remarkable."

The designers profiled in this book have had varying experiences integrating new media into their everyday work. Some have embraced new media to the point of creating new companies to accommodate interactive design exclusively. Others have elected to focus primarily on design and partner with new media specialists for development expertise. All have realized the need to collaborate with a broader range of creative and technical experts than ever before.

Regardless of how they've chosen to articulate new media, all have had to grapple with hard issues: How will getting involved with new media affect the budget? Will new media pay for itself? Will it mean new equipment and additional staff? How will it impact the workload? Who will provide the necessary expertise? Who will deal with the clients? How will the projects be billed?

And what about graphic design? How is the field being affected by new media? One can't help but notice the emphasis on graphic design is certainly different in new media, but is it less important?

This book offers answers to these questions, and more, by profiling others who have profited from their successful journey into new media. Whether you're looking to completely transform your business or collaborate with others as you plan your move into interactive work, it is my hope that these stories will guide and help you as you face similar issues in your design career or business.

As Galie Jean-Louis of MSNBC states, "I can't reiterate enough how this will become integrated into our lives very quickly.... It's not just a 'Jetson' notion anymore. And we are the ones who—in the next six months, five years, the next millennium—will be the architects of these pages, these textures, these surfaces."

THE Second Computer Revolution

by Katherine McCoy

This book is about a different revolution—a second computer revolution. Computers are now enabling a deeper level of visual communications, offering more than a drawing, composition or production tool for graphic design. Electronics are becoming the delivery medium, the context, the content and a conceptual world as well. Communications design is no longer linear and two-dimensional; it is hyperfluid and six-dimensional, incorporating real time, motion, sound and interactivity in addition to the traditional X and Y coordinates.

Audience-customized communications offers powerful potential. New interactive technologies make it possible to individualize all kinds of products and services. Today there is hardly a designer who doesn't begin the workday by booting up the Mac. In the past ten years, the computer has thoroughly transformed the graphic design practice.

Increasing amounts of information are delivered to audiences via screens. Will a conventional printed piece soon be the exception rather than the rule for the typical output of graphic designers? Digital graphic design shapes computer operating system logic and displays, software interfaces, smart product interfaces, hypermedia, electronic publishing, interactive education and information systems and digital interactive exhibits, as well as Internet applications and the exploding world of Web sites. Nearly all conventional forms of design—including editorial, corporate publications, advertising, packaging, exhibits, signage, products and interiors—are infused with electronic media and intelligent digital characteristics that interact with their users and audiences.

Most of the pioneering graphic designers who specialize in new media today have had to acquire this knowledge informally, largely through trial and error, in the context of professional design practice. There remains an educational vacuum in this emerging field. Few offices have university-trained design staff for this new discipline, and only a few true design programs exist to date. Too much of new media is covered, by default, by people untrained in visual communications methods and form-giving. Electronics technologists, as well as the thinly trained graduates of a host of lower-level schools, make many of the design decisions in the digital world. Many schools at the community college level are rush-ing to offer roughly formulated programs on Internet design. Most of these programs offer only superficial software instruction and are far too short and shallow to meet the challenges of new media design. To become a professional discipline, this new field needs fully formulated curricula on the university level. A solid design education in the creation of new media may take more than four years; graduate-level study may be necessary to achieve depth and expertise.

This vast field desperately needs to define its process and professional content and develop a philosophy, a curriculum and an identity. It even needs a name. The terms *new media* and *multimedia* are problematic; their vagueness and ambiguity contribute to the misconception that anyone familiar with software tools is qualified to practice design. *Computer graphics* and *Web site design* describe the product rather than the conceptual process of designing.

So what is the name to be? Multimedia design? New media design? Digital graphic design? Computer-delivered visual communications? Screen-based communications? Electronic communications design? Words come loaded with the baggage of association, and most seem inadequate or inappropriate to describe this new process. Somehow the product, or at least the output medium, is easier to describe. But as professionals, we need an identity for

the conceptual process and professional service. *Graphic*, as in graphic design, hardly seems applicable, referring as it does to the venerable tradition of paper-based multiple mark-making. Fine art printmakers and the printing industry also claim ownership of the term *graphics*.

The adjective *visual*, as in visual communications, seems inappropriate now that sound has been added to our communications tools. *Design*, however, remains at the core of our process, with its reference to conceptual analysis, planning and strategy. Because *communications* is our goal, I find myself using the term *communications design* more frequently than *graphic design* in these days of rapidly changing practice. Perhaps *digital communications design* best describes our new realm.

But is it graphic design? Louise Sandhaus of the California Institute of the Arts poses this rhetorical question. Is new media design a subset of graphic design or a sibling of graphic design under the larger umbrella of communications design? Or is this field destined to evolve into a mature and separate design discipline, as autonomous as interior design, industrial design or illustration? Another Cal Arts graphic design educator, Edward Fella, has argued that conventional graphic design and the emerging field of digital communications design are as different as photography and film. University design programs and our professional design organizations are currently debating these possibilities.

When compared to visual communications subsets like typography or editorial design, digital communications design has a greater magnitude of difference. While this new area draws on many traditional graphic design skills and methodologies, it also opens up a whole new universe that is largely conceptual and much less tangible. It employs a new medium—electronic information processing—and new output, which is often interactive and dynamic. This is a new world of experience for our audiences—a conceptual space, a digital environment populated with virtual personae and communities in continuous flux.

As a result, digital communications design is far more conceptual than traditional graphic design and requires a much deeper understanding of the communications process. It goes much fur-

ther than making nifty images on a computer. To create comprehensible virtual communication spaces for our audiences, designers must grasp profoundly more complex fundamentals of how human beings receive information, conceptualize information space, navigate and orient themselves, understand, respond, make choices, change behavior and express themselves. Communications theory (including semiotics) and methodology are applicable, along with cognitive and perceptual psychology and strategies from the social sciences and cultural anthropology. Some designers must be literate in computing science. Neighboring disciplines, such as urban design, film, music composition, drama and storytelling, are useful to designers through analogy. All these sources are rapidly recombining into whole new theories and methods in this wide-open environment. The real challenge is to explore, develop and codify a new language of interactive design that ranges from the very technical and structural to the sensual and cultural interface of virtual communication spaces. What serves as an interface in print design—a table of contents, page turning and an index—has become incredibly more complicated in the digital domain.

Interactivity compels the greatest magnitude of change to the graphic design process. Interactive nonlinear communications creates conceptual spaces that are far more complex than the two-dimensional spaces traditional graphic designers are so expert at shaping (and our audiences at understanding). Interactivity requires new kinds of way-finding through the information, experience or the task at hand, as well as the skillful pacing of time. When compared to non-interactive design projects, form-giving comes at the very end of greatly extended conceptualizing stages. The complexity of interactive communications projects frequently can only be handled by teams of specialists offering a wide range of expertise from communications design and neighboring disciplines.

Much of this sounds extremely scientific, and it is. The knowledge ante has been upped several magnitudes. Those who come to design for its individualistic artistic expression will need to assimilate a new culture and either acquire extensive new expertise—theoretical and technical—or learn to partner with those who do.

On the other hand, digital communications design must find a careful balance between the conceptual and the aesthetic as it evolves. Design is a narrow bridge between the worlds of science and art, the analytical/rational/cerebral and the intuitive/subjective/sensory. It is critical that we not abandon the sensual and emotional, including the expressive contributions of graphic design imagery and typography. The designer's imperative is to mediate between human beings and technology—to warm up, humanize, animate and materialize digital communications for the user. In doing so, function will be served and communications enhanced.

Since the advent of TV and computers, the audience's relationship to the electronic screen has been predominantly "frontal" and passive. To activate and animate screen communications, we need to develop a visual/verbal/audio/motion/interaction language, a new vocabulary of both conceptual and visual strategies. Just as the first movies used theater as a model before evolving a film language, new media must move beyond the metaphors of print and other familiar media to form an eloquent language of interaction.

Steven Johnson of *Feed*, an electronic magazine, sees this happening already. He predicts that the Web experience is on the brink of becoming an art form and therefore needs a nuanced vocabulary. He critiques current efforts to develop a language of interaction as narrowly utilitarian. Johnson contends that as the expertise of designers matures—with that of our audiences— more poetry and mystery can be added to the equation. More experienced users can tolerate and even demand a broader interaction where chance, randomness and unpredictability are even considered virtues.

What are the forms—visual, verbal, acoustic, spatial, temporal, structural—that build rich, compelling and memorable experiences? We await the codification of strategies into signposts for designers on the electronic superhighway. Barbara Kuhr, design director of *Hotwired*, compares today's design environment to the early years of motorized transportation, when "horseless carriages" were defined more by their antecedent than by the new paradigm of "cars" that eventually emerged and persists

today. She now asks, "When will we design cars?" She anticipates the codification of some design paradigms to guide both designers and their audiences in the digital domain.

But perhaps digital design and the language of interaction will not be as rigid as the paradigms of cars or motion pictures, both of which have remained fairly constant once defined. Film is a physical medium and cars are physical hardware that move real bodies of flesh and blood. Electronic technologies are immaterial and in constant flux and evolution. Will the nature of digital communications remain fluid? A language of interaction will be like a vernacular spoken language in constant mutation—more like English than Latin. Maybe there never will be fixed "rules," but rather constant evolution in a medium well-suited for designers who are energized by experimentation. This is an exciting prospect, appropriate to designers' special abilities to respond rapidly to change and solve problems on the fly. On the other hand, it could be very uncomfortable for designers who prefer "rules" and educational programs that need curricular structure.

Interactive digital technology is forcing another major paradigm shift that humbles as well as frees the traditional graphic designer. The digital delivery of interactive communications design media allows our audiences to "finish" our work. Communications design "pieces" will increasingly be delivered to audiences as potential experiences to be initiated by each receiver and "read" in a unique way based on each receiver's preferences, interests, values, needs and even moods. Web sites, CD-ROMs, interactive TV and advertising, and customizable software are examples. Designers find they cannot control many variables of how a home page downloads, not only because of the vagaries of differing electronic formats, but even more due to the preferences of their audiences, who are increasingly opinionated and educated in the subtleties of form in typography, imagery and sound. Interactive media encourages audience members to create and add content.

This environment requires a much different visual design strategy than that of the traditional perfectionist designer. What are the implications for graphic designers trained in the modernist traditions of clarity, formal refinement and professional control? We

can no longer think of our work as precious, perfect artifacts or discrete objects, fixed in their materiality. The designer is no longer the sole author, realizing his or her own singular vision. This forces a reordering of our design intentions. The designer is an initiator, not a finisher—more like a composer, choreographer or set designer for each audience member's improvisational dance in a digital communications environment.

Audience-customized communications offers powerful communications potential. New interactive technologies make it possible to individualize all kinds of products and services. Interactive electronic communications can be configured by each user to deliver what they need when they need it, customizable to their changing skills, characteristics and context over time.

The unfinished quality of online electronic media also offers valuable opportunities as well as challenges. For instance, the imperative to continuously update and upgrade a Web site to encourage repeat visits has all kinds of organizational implications, such as long-term budgeting and staffing and maintenance of design integrity. But it also allows the designer to dynamically evaluate the success of an online piece through feedback on the number and duration of audience hits. We can now measure what is interesting and who is interested. Continuous cycles of iteration, testing and redesign are possible and practical. A piece is always a prototype, open to refinement and enhancement.

Designing for experience and personalized interpretation is an opportunity to engage the audience's interpretive powers and to counter the passive "couch potato" syndrome. Interpretive design can challenge the viewer to participate, react, think and affect the outcome. Audience choice making and active feedback promise a deeper level of interactive communications.

New media designers must understand how people construct meaning when they encounter information, objects or situations. Postmodern literary criticism and art theory offer promising strategies for the new interactive communications channels rich in dialog, debate, transaction and negotiation. These deconstructive theories of discourse explore the potential for dialog between sender, message and receiver, and shift the major

responsibility for meaning from the sender and message to the receiver. Meaning is construed through the active participation of each reader/viewer who interprets multivalent nonlinear messages. Timothy Druckery, in a *Siggraph* essay, calls for theories of interactivity to be joined to theories of discourse.

We are coming to see digital technology as a sort of artifact, in spite of its immateriality. We already collect music CDs, and now CD-ROMs. Soon, family photo albums will be in digital format. Many graphic designers have digital image banks and sound collections stored in their computers. And so do our audiences, many of whom continuously sample elements that appeal to them and then recombine them into their own Web compositions. Twelve-year-olds and grandmothers now know the difference between Times Roman and Univers. Audiences are becoming fans, connoisseurs and critics of digital communications design.

Many designers are worried about this amateur involvement in design. Professionals fear that their expertise will lose value in a world where anyone with a computer and easy-entry software can make design and publish it through accessible desktop Internet tools. On the other hand, as our audiences become more visually educated and discerning, their constant appetite for the new will cause clients to seek an even higher level of professional design vision to keep their communications compelling and competitive in an ever-expanding communications environment. Audiences demand the richness and performance of design expertise that elevates messages from informational data to truly resonant communications. Agile communications designers can only benefit from this challenging new world.

bio Katherine McCoy is a senior lecturer at Illinois Institute of Technology's Institute of Design in Chicago, and is a visiting professor of the Royal College of Art in London. As partner of McCoy & McCoy Associates, she consults in graphic design, design marketing and interior design for cultural, educational and corporate clients. She writes frequently on design criticism and history, and has co-produced a TV documentary on Japanese design. An elected member of the Alliance Graphique Internationale, she is past president and chairman of the board of the American Center for Design. She is a Fellow and past president of the Industrial Designers Society of America, and past vice president of the America Institute of Graphic Arts. She was co-chairman of the Department of Design at Cranbrook Academy of Art for twenty-three years. She recently co-authored and designed *Cranbrook Design: The New Discourse*, a book published by Rizzoli International. She has also chaired Living Surfaces 1, the first national conference in the U.S. on multimedia in graphic and industrial design.

WHAT Role WILL Designers PLAY IN THE Future OF THE INTERNET?

by Roger Black

Now that designers are learning to embrace the Internet as a new arena for design, they're also finding out that what's cool isn't so important any more. During the last four years, something else has been happening. Web sites have been moving toward their real nature as places for commercial transactions. Online retailing continues to expand—now you can buy a best seller or a first edition, a car, a plane ticket or a prize-winning Hereford bull on the Web. Business generated on the Internet is growing exponentially every quarter.

The Web is also terrific for what I call information transactions. You can get answers from company customer service departments or download a detailed map of recent excavations in the Valley of Kings for a homework assignment.

In the United States alone, some 25 million people get on the Web at least once a week. As the Internet quickly is becoming the conduit for anything that can be digitized—all information and all entertainment—its future is virtually limitless. In fact, existing search engines can't really keep up with the increased volume of information now available on the Internet. Developing more sophisticated search engines is currently a top priority in the online world. Somehow, I think they will never catch up. And in the meantime, design plays a key role. Designers create the signposts on the Net and light them up.

Web sites need good design even more than print. So far, many Web sites are badly edited, badly designed and badly engineered. Just getting people to your home page isn't enough;

The Internet inevitably is pushing designers into interdisciplinary work. Designers must get involved with engineering and software development. Print designers must learn something about animation. In order to satisfy our clients' needs, we may have to become video directors or editors as well as marketing experts, business consultants and strategic planners.

you need to bring them inside. Reward them once they've arrived, and try not to confuse or frustrate them if you want them to come back to the site.

In the future, design will become more sophisticated and complex as increasing bandwidth allows us to use more video and sound on the Web. Even though we have begun to establish certain conventions, the many issues involved in navigation and changing software mean that there's a constantly shifting landscape for design.

The Internet inevitably is pushing designers into interdisciplinary kinds of work. Designers must get involved with engineering and software development. Print designers must learn something about animation. In order to satisfy our clients' needs, we may have to become video directors or editors as well as marketing experts, business consultants and strategic planners.

Designers are gaining a role in creating and adapting content for the Web and in making transactions easier by creating bet-

ter interfaces. With books and magazines, the designer retains a definable role and the product is fixed once it is printed. One of the often frustrating realities of the Internet is that it's always fluid and designs can be altered as soon as they appear. At the Interactive Bureau, we say that the new media environment can make anyone—clients, readers, customers—into publishers. It can also make them think they are designers.

Successful Internet design depends not only on brilliant graphics and navigation; it is also a collaborative process with the client/customer. Building a site involves high levels of management and communication. You must learn how to work closely enough with clients to understand what their needs really are.

Interactive Bureau's affiliations with colleagues in other countries take advantage of a network that was first established in the print world. Some of these relationships began in the days of *Rolling Stone* magazine! But it was the development of the Internet itself that has allowed this network to really evolve, since people in different countries can now share resources and ideas so easily.

We're all wondering where the Internet is going. But we know it will be everywhere. I think we will cease to think of it as any one particular thing—just as you aren't as aware of the television itself as you are of specific television programs. The Web itself will fade away and take a nostalgic place in media history alongside old episodes of *I've Got a Secret*.

During the next decade, the Internet will stop being considered an adjunct of computers. The Net is already converging with the TV and entertainment industries. It will lose its borders and become more integrated into everyday life in many ways. As more objects incorporate chips, you'll be able to use the Web in the car to get directions or find the name of a restaurant you might visit. You'll be able to ask your stove to identify the herb in that recipe, and the air conditioner will know about the heat wave before the sun rises.

With this proliferation, good Internet designers will have their work cut out for them for a long time to come.

b i o Roger Black is president of Interactive Bureau and author of *Web Sites That Work* (Adobe). He and his international team have designed Web sites for Discovery Online, *USA Today*, @Home and HBO. Winner of the National Magazine Award in 1975, 1976, 1977 and 1978 as associate art director and art director for *Rolling Stone* magazine, he continues working in print through Roger Black, Inc., having recently redesigned such publications as *Reader's Digest Worldwide*, *Red Herring* and *Working Woman*.

THE Medium IS THE Message BUT WHAT Language ARE WE SPEAKING?

by Randy Weeks

Life sure was harder when my folks were growing up.

Why, I've had indoor plumbing and electricity all my life. At the flick of a switch I can brighten a room, warm a winter's night, get the latest news or talk to a friend across town or across the world, not just across the back fence. And, except for the occasional camping trip, I've certainly never had to put on my shoes and walk through the snow just to go to the bathroom in the middle of the night.

I haven't had to walk across a room to change a TV channel in decades. I know who's on my phone before I answer it. I haven't waited in a bank line (unless I chose to) since I was a teenager. When I cut wood, it's for burning in fireplaces for ambiance, not heat, and I get to eat grapes and strawberries all winter and enjoy cold air all summer. Sometimes it feels like we're not even the same kinds of beings that our parents and grandparents were. In fact, we're probably not.

We're far more dependent on one another than they were. We may not know each other as well in our world as they often did in theirs, but our interdependency is far greater, just as theirs had become far greater than that of their parents before them.

The vocabulary of this interdependence is impressive all by itself, even before you get to be an adult and have to deal with everything from bank statements to Internet connectivity.

Various sources have credited the average U.S. high school graduate today with a vocabulary of thirty thousand to sixty thousand words. Either of those numbers seems like a lot, until you consider how many words we have to know just to be able to talk about the world in which we live.

In the past, countless brilliant men and women lived and died in obscurity, their ideas never developed, heard or shared by the world. Today, those same unknown people can publish to the same platform used by presidents, media empires and universities.

In 1926, a study at the University of Iowa produced a report that claimed the average six-year-old had a vocabulary of 2,600 words. Consider words gained and lost in our popular use since then, and my guess is that the mere addition of such concepts as TV, radio, day care, commercials, malls, magic markers, credit cards, CDs, remotes, Sesame Street, microwaves and the myriad brand names and designer whatchamacallits of our modern world make the vocabulary of today's six-year-old an entirely new and expanded edition of the *Encyclopedia Britannica* by comparison.

What we knew as science fiction thirty years ago is reality for today's kids. They know more about electronics and video than most adult engineers could have imagined a generation or two ago. They're taught more about sex in elementary school than our folks told us right up to the day before we got married. There is so much stuff you have to know just to have an intelligent conversation today.

The complexity of our world is staggering, and the interdependence that allows us to have central air, reliable electric and phone service, trash pick-up, supermarkets, day care centers, cable TV, Beanie Baby collections, video conferencing and pizza delivery has made our lives simultaneously easier and far more complicated.

And life is only going to get more complicated—fragile in its interdependence and strong in its intricate connections and related support systems.

Imagine how many more words and concepts you know than the average person knew in Europe or the U.S. in the eighteenth or nineteenth centuries. It's kind of scary. And this information is now being shared faster than ever, making the pool of information available to each of us larger still with every passing day.

But that's not exactly the subject I'm supposed to be addressing for this book—or is it?

Life sure was simpler when our folks were growing up—or was it harder? Which? Both?

Yep.

In the past, countless brilliant men and women lived and died in obscurity, their ideas never developed, heard or shared by the world. Today, those same unknown people can publish to the same platform used by presidents, media empires and universities. More voices are heard now. More ideas will come forth. More competition. More change. Faster change—much faster.

Interdependence and cooperation are essential to success—even survival—so we specialize. We focus our energies on what we can master in the growing complexity of modern life.

We create new jobs, new industries, new mythologies for our culture as we adapt new relationships between them all. And life gets both easier and harder all the time. The better we communicate, the more effective we are and the more successful we can be in our lives.

It's practically a full-time job just keeping up with the major shifts in technology news, let alone with the micro-developments that can render your coolest new design idea a browser-crashing clunker for half of the visitors to a Web site.

I don't think we can begin to predict what the future of new media is going to be.

To imagine that our world tomorrow will look like the world we see today is as ludicrous as it would have been for a blacksmith to imagine in 1880 that his skills would always be in high demand and that horses would always be the most effective way for people to get around.

I'd rather partner with others who pay attention to the market and related businesses and needs who are current in their disciplines and skills, and who hope that our mingled knowledge and insights will yield a few of the as yet unimagined ideas of tomorrow.

So here, subject to change without notice in a matter of months—if not moments—are a few of my present thoughts on the cooperative production of new media.

❶ Build effective partnerships. I know there are exceptions to every rule (and exceptions to these exceptions), but for the most part, we should work cooperatively to succeed in the ever-changing electronic marketplace. The people who build a car are seldom in the same department as those who design or market it. In a world of ever increasing complexity, specialization is almost always necessary in order to excel. Family practice doctors are swell, but when you need serious surgery, a specialist is the ticket. It's pretty hard to do everything great. It's also hard to effectively communicate across the camps, but if done properly, it's a heck of a lot more effective than trying to do it all yourself.

❷ Find a liaison who can speak the language of both disciplines well enough to manage Web projects effectively. In our experience, the difference between a project where there was at least one talented liaison and a project where there were none was tremendous in terms of cost, quality, timing and customer satisfaction. In the world of mixed-discipline tools, myriad e-mail attachments, Web servers, mock-ups and ad campaigns, the person who can speak each camp's language a little bit is worth a lot to both. Amidst the flurry of sketches, HTML standards, scripting, PhotoShop files, Gantt charts, proofs, XML, Java-embedded every

things, browser wars and firewalls, an individual who knows enough to listen and communicate, manage, move and coordinate the meetings, issues, changing costs and arising needs during a project is worth even more to everyone involved. Find one. Keep him happy.

3 Respect the knowledge and professionalism of each other's efforts. It's about as cool to bash IBM or Mac as a platform as it is to badmouth a loved-one's family members. Cars need wheels as much as they need motors, seats and steering wheels—no one part is really cooler or smarter or altogether better than the other. Taking time to learn all you can about each other's efforts will result in some pretty great projects, completed on time, on budget and at a profit.

4 Don't expect all team members to know or "get" the stuff that is new to them. Every new team of Web programmers and designers has to face start-up problems such as format conflicts and Mac vs. PC compatibility. If you can afford to have both plat-forms running and kept up to date in your company, it might be a good idea to do so. Either way, communicate. Talk about methods of file sharing, image conversion and data transfer. Learn about ways to transfer files; use threaded message centers for sharing project notes. Don't talk down to each other when discussing functions and skills that may be better understood by one group than the other. That kind of attitude is for people who are afraid of each other. What are you afraid of? A meeting of the minds is a terrific learning opportunity. Make good use of it.

5 Always include everyone in meetings and discussions that involve the project. At the very least, make a call, review the issues and decide if representation is needed at a meeting. A pro-grammer should never assume that the client or the advertiser will "figure out" the programming he's written. The agency does-n't want to be surprised that the minor color, shape, layout or other change quoted to the customer is actually going to take days of reprogramming. With a quick call, e-mail or impromptu meeting, those managing the contract at the agency can avoid reworking and delays on seemingly simple changes. Some of these changes may affect complicated code.

6 Remember how fast computer technology is moving, and how quickly today's killer app is yesterday's Pong. Today, the changes in new media seem to come so fast that we can barely keep up with our current level of expertise. Companies planning to compete in new media and the digital world in general must be familiar and competent in communication technologies.

But can you be an expert at everything? Do you know every difference between every version of every browser with regard to every Java, Java-script, ActiveX, animated GIF, table layout, frame design, download method, XML, SGML, PC vs. Mac display/ load/transfer consideration? Neither do the experts. They may know them today, but this afternoon they'll have to brush up. Next week, they'll have to be talking about changes, and next month they'll be loading patches, adjusting code and writing new, better and crash-free ways of doing almost everything. Several times during that month they'll be alternately amazed, horrified and humbled by what they see going on in the industry and the diverse pool of experts hawking their wares and services to the world—and these are the best and brightest of them.

Clients with serious needs for interactivity, back-office data sharing or impressive media communication are not well served by WYSIWYG applications alone. Neither do they find it very satisfying to use their favorite talented programming outfit to conceive, design, test and implement a marketing and brand campaign, since those skills are not likely to be a programmer's strong suit. There are some who do it all very well, but I'm of the opinion that they are the exceptions in the new media world, and there is far more work to be done out there than even the largest and best-integrated agencies can handle by themselves. If you're not big enough or rich enough to hire an incredibly bright and experienced Internet staff, get a good partnership going and help each other stay on top of the wave.

7 Computers aren't people, and people make the difference. Even though it's been mentioned, I can't say enough about the relationship factor. Computers can make smart people feel dumb, and people don't like to feel that way. For many people, it's dehumanizing to have to work with a computer at all. If those

who know the language and applications of the computer and the Internet make others feel worse by talking down to them and losing them in tech-talk, it becomes almost impossible to have a relationship, and forming relationships is essential to producing new media projects. Much of what we're doing these days is pretty complicated. Most of it has never been done, so we're all figuring it out together. The loss of a central, effective person has seriously hampered more than one seemingly well-oiled Internet machine. There are a few people I still miss among the agencies with whom we worked.

8 Make a plan for the partnership as well as for the project. Just as street signs with pictures help us find our way regardless of language barriers and a good architect makes a complete blueprint before any bricks get laid, a good specification, combined with a good development plan, is essential in electronic media. Drawing good pictures for each other and revising them as the situation dictates will help us work together effectively. It will help us get the job done in spite of the language barriers that will continue to exist between the myriad talents and skills being brought together on increasingly sophisticated new media projects.

Macs and PCs don't always talk to each other. Don't take it personally. Make a plan to deal with it. FTP is better than Fed-Ex for lots of stuff, but not if some team members are unable to send or receive electronic content. Make a plan to deal with that.

A message center—threaded discussion forum, simple upload and file sharing area—is not as hard to set up as it used to be, and the improved speed and efficiency it brings is worth the effort. Coming up with agreements for standardization in tables, programming style, platforms, image types, naming conventions and other design elements will save lots of time and money. Decide how you will name JPG, GIF, HTML and other files/tools for ease of communication and manageable updates.

A good mechanic can drive a car and assess its performance. He can listen to the engine and tell you what is most likely wrong with it. A builder knows what structure will pass inspection and what materials will work best at the lowest cost. A good designer knows what colors, layouts and presentation will best communicate the client's message. We should take advantage of that as much as possible in a cooperative approach to new media. Some of us can be all things Internet to one or two customers—for a while. But most of us will be most effective when focused on what we do best; in partnering with others who contribute value to the other parts of the project *they* know how to do best.

Because life is both easier and harder today than ever before. And we're still playing Pong.

We haven't really seen anything yet.

bio Randy Weeks is founder and CEO of NetCrafters, an interactive design company specializing in programming for automation and ease of use in Internet applications. Visit their Web site at www.netcrafters.com. Clients include Procter & Gamble, Belcan, Jacor Communications, Databank Corporation, the Greater Cincinnati Convention & Visitor's Bureau and a number of educational and industrial customers. You may contact Randy at randy@netcrafters.com.

case

study 1

THE DESIGN

OFFICE

T.D.O.

INTERACTIV

New York City

Joseph Feigenbaum and his wife founded The Design Office in 1985, and were early proponents of electronic design. "At that time, I went to a demonstration of the 'Lightspeed' computer system," he relates. "I came away absolutely convinced that computers would revolutionize the business." They bought their first Macs in 1986 and targeted corporate communications.

Feigenbaum personally embraced the concept of new media in 1994 while observing his five-year-old daughter using educational software on her computer. He noticed that she interacted in a focused, one-on-one relationship with the computer while working at her own pace and following her own path. "In all categories, other than social interaction and communication skills, new media appeared to me to be superior to the classroom as a teaching tool," says Feigenbaum. "This struck me as remarkably compelling. The media, when done well, impressed me as a dramatically powerful communications tool with unique attributes that needed to be further explored, identified and developed."

> While most of our new business is in technology development, new media has also expanded our conventional business.
> —Joseph Feigenbaum

Feigenbaum started to wonder how his conventional design firm could segue into new media design and development. "In early 1995, I met a charming but unproven interface designer and programmer with whom I shared remarkably similar viewpoints related to new media," he explains. "I found the solution to my year-long pursuit by literally 'hiring' new media." The Design Office then set out to position itself in new media design by investing funds to cover one year of prototypical development, purchasing specialized equipment, software, reference books and publications.

After seven months of learning how to produce interactive multimedia, The Design Office was just about to bring out its first CD-ROM samples when the Web burst on the scene like a tidal wave. "We reoriented to the Internet, which was actually relatively easy because it required a downgrade in programming, art and quality requirements," says Feigenbaum.

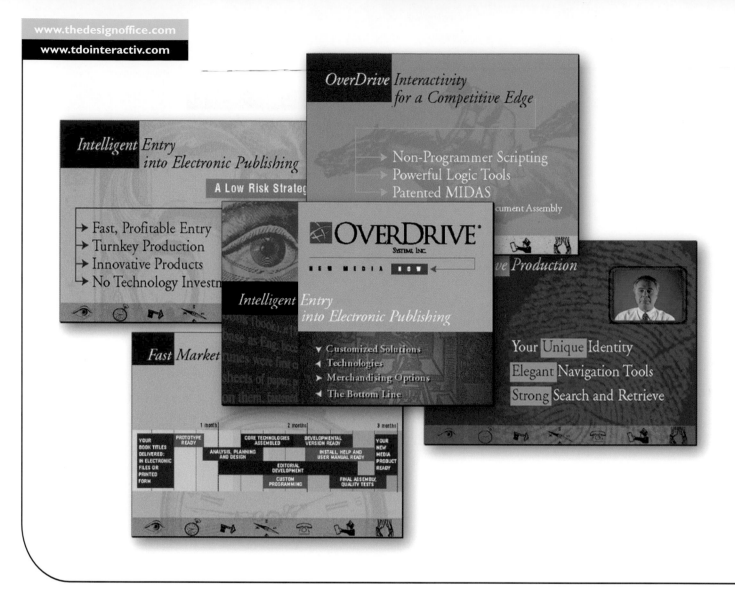

Overdrive Systems, Inc.

*The Overdrive presentation is a powerful sales tool that gives
prospective customers a complete representation of Overdrive's
software products, development services and integration and pro-
duction methodologies. The CD-ROM presentation can be used as
a freestanding sales pitch, digital leave-behind, or, with the volume
turned off, a speaker support device. The presentation features
screen settings that allow the user to customize speed and volume
for best performance. It also incorporates intuitive visual menus,
numerous animations, voice-over, QuickTime videos and e-mail ca-
pabilities in a lively and entertaining interface.*

Designers: *Andrea Flamini, Joseph Feigenbaum*

Programming/scripting: *Andrea Flamini*

From there, Feigenbaum pursued every poten-
tial selling opportunity he could think of, con-
tacting existing as well as potential clients. The
Design Office's marketing plan was based on in-
tegrating the knowledge of an experienced de-
sign and communications firm with new media
and print for promoting consistent identity and
messaging in all media.

This approach brought some success. In just
three short years, The Design Office has almost
doubled its business volume. However, there
have been ongoing challenges. "To our disap-

Personnel Needs

Producing a Web site requires the pooling of many talents. The average project team at the Design Office typically consists of:

- creative supervisor/project manager
- business/marketing consultant
- account manager
- copywriter
- lead programmer
- second lead programmer and/or application builder
- interface designer and/or graphic/information designer
- illustrator/photo imager
- proofreader
- break tester

pointment, we found the electronic market predisposed to dismissing design firms of conventional backgrounds," says Feigenbaum. "Our proposition of solid, strategic marketing and communications principles overlaid with electronic delivery was ahead of its time. It appeared that the medium was so little understood by marketing executives that they found

Home Financial Network PC Banking ATM Interfaces

Home Financial Network Home ATM is a PC-based Web home banking product sold to banks that want to bypass the expense, time and trouble of producing a home banking system. Banks purchasing the Home ATM product are offered a totally unique, custom interface design or a more budget-friendly choice from a catalog of predesigned interfaces. Their identity is then applied in a modular fashion. T.D.O. Interactiv developed Home Financial Network's catalog of twenty-four modular interfaces. Specific target markets include GenX, Wall Street, Lifestyle and ATM machine interfaces.

Designers: *Joseph Feigenbaum, David Green, Andrea Flamini*
Programming/scripting: *Andrea Flamini*

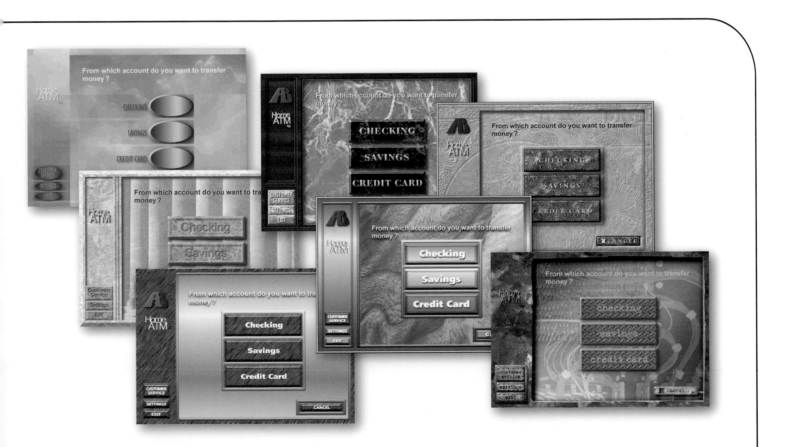

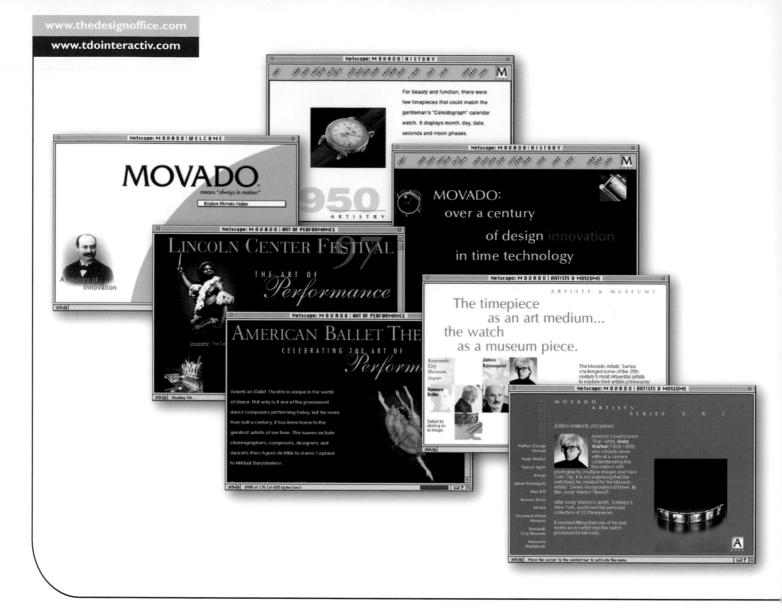

www.movado.com

The Movado Web site is actually three sites offered at varying levels of technology. While one version utilizes extensive Java script, tables, frames and animations, another delivers the same content statically. The best site for any one browser is selected via a detection script that identifies the incoming browser. Movado.com incorporates a controlled navigation that allows users to explore, while subtle limitations in navigation direct users through specific content.

The site features a watch catalog and dealer locator. The dealer locator search function overlays zip codes with latitude/longitude databases, allowing the user to select a specific mileage radius surrounding his or her location. Dealers are served up via a randomizing script that guarantees fair and equal representation and eliminates inequitable alpha-numeric sequencing.

Designers: *Joseph Feigenbaum, Andrea Flamini, David Green, Kleber Santos*

Animation: *Rowland Holmes*

Programming/scripting: *Rowland Holmes, Andrea Flamini*

Writer: *Deanne Torbert Dunning*

more comfort in pure new media kids sporting heavy 'tech speak,'" he relates.

To counter this bias, The Design Office launched a new company, T.D.O. Interactiv, in late 1995. They created new marketing materials that focused heavily on programming, incorporating "tech talk" and illustrations of technological solutions that achieved measurable results. Says Feigenbaum, "Almost immediately, we began to close new business deals and win in competitive bid opportunities."

In the last three years, The Design Office has developed twenty-four Web sites and seventy-four online banner ads. The firm has designed and engineered CD-ROM presentations, electronic directories, screen savers, calculators, communications channels and global resource distribution systems. As it turns out, Feigenbaum's integrated marketing proposition has become extremely salable. "Ironically, we found ourselves retained to redevelop many other developers' first generation 'brochure ware' Web sites," says Feigenbaum. "As understanding increased and quantitative measures were applied, these clients found their sites to be devoid of the very marketing principles we had been unable to convince them were missing."

The Design Office has found that roughly 25 percent of its clients buy the full range of their integrated communications services (including corporate identity, marketing collateral, packaging, Web sites and interactive sales tools), while 40 percent buy exclusively new media services and consulting. Clients often hire them for both development technologies and marketing/communication skills. A mere 35 percent buy only their conventional media services.

"While most of our new business is in technology development, new media has also expanded our conventional business," Feigenbaum relates. "Because we understand software and data engineering, companies that engineer technologies have begun to look at us to help them market their products and services."

Tips

1. **Do not attempt to be all things or fill all needs.**

2. **Define and analyze your strengths and weaknesses.**

3. **Seek input and support outside your design expertise.**

4. **Forge creative partnerships with those who complement your talents and round out your capabilities.**

5. **Build your knowledge base by reading related publications.**

6. **Attend pertinent seminars and meetings.**

7. **Spend time online assessing and analyzing developments, content and technology.**

8. **Define your point of view, values and principles.**

9. **Define your value to clients by associating your creative developments with real, definable business objectives.**

10. **Seek to quantify your work against measurable criteria, which will ultimately help you and your profession.**

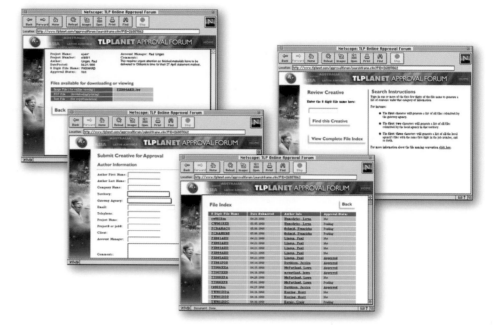

Citibank-Elton John Global Online Approval Forum

Created for Citibank and TLP (a division of Omnicom), this site lets creative professionals at agencies and corporate entities around the world submit their creative strategy documents, visual concepts and copy to global approval sources for comment or approval, all in a matter of hours. The site not only speeds approval, it ensures worldwide marketing program consistency. The Approval Forum assures security by verifying registrants and providing a password.
Designers: *Joseph Feigenbaum, David Green, Kleber Santos*
Programming/scripting: *Rowland Holmes, Craig Kauppila*
Writers: *John Fatteross, Billie Best*
Consultants: *Monty Kiernan, Billie Best*

The Design Office has felt the impact of new media in other areas as well. "New media is a team effort," Feigenbaum explains. "It has expanded my own interaction with my employees, who bring a much broader range of talents

and backgrounds to the project. New media has also required us to develop collaborative relationships with other highly specialized professionals."

The Design Office has crafted critical relationships with individuals and companies in interactive application development technology, copy and content development and electronic photography, as well as with hardware, software and connectivity providers. Notes Feigenbaum, "While conventional design, in some cases, may be a one-person initiative, new media is not. It demands equal amounts and a fine balance of content development, information, visual and graphic design, scripting, programming (often in diverse languages), video and sound, and occasionally cognitive and process engineering. Electronic communications has made a virtual collaboration a truly functional reality today."

Feigenbaum and his group bring two underlying principles to all of the Web sites they design. The first is the belief that all users are learners. Content is treated as what Feigenbaum calls "infotainment," requiring the user to explore and discover the information they are seeking. The second, specifically for "tool" applications, is to design a direct and intuitive interface that speeds the user to this information in the fewest steps.

Feigenbaum admits that the firm's work in Web site development has led to projects that no longer fit comfortably under the heading of "design." "Much of our most important work is now cognitive and technical engineering and business-process mapping," he relates. "While all of our projects include both communication and graphic design expertise, these, in my opinion, are no longer the critical values delivered."

After twenty-five years in the business, new media has offered Feigenbaum a new creative challenge. "I find that new media has rekindled my excitement and expanded my interest," he explains. "I have to focus more closely on how users interact and experience the work we do. Feigenbaum describes new media as a mixture of science, communication and art, with every new project yielding a large body of new information and experiences. "New media expands the designer's role to encompass physical functionality, motion, sound and a new depth of information delivery," says Feigenbaum. "New media continues to define itself based on every designer/developer's production. . . . There is always new territory to be covered."

case
study 2

DUFFY

DESIGN

Minneapolis & New York City

New media became a joint effort when Duffy Design and Fallon McElligott decided to pool their talents in 1996. "Until then, we felt that the way we were approaching new media wasn't in the best interests of our clients or ourselves," recalls Neil Powell, design director at Duffy Design, New York. "Because it was so new and the learning curve so great, we felt we needed to put a special effort behind producing new media projects. Out of that came a new interactive company under the Fallon McElligott umbrella—Duffy Design Interactive."

Duffy Design Interactive is staffed by Fallon account executives and Duffy creatives who work in tandem with staff programmers to produce all interactive work. Billing itself as the "first interactive company built by marketers," Duffy Design Interactive believes the focus should be on the consumer, not the delivery. "I think it's pretty easy to use the bells and whistles that come out of programming and impress people with that on a Web site, but we wanted our sites to have more strategy and really be a branding tool for our clients," says Powell. "In order to accomplish this, we pulled together

> What's really exciting, especially having been a traditional two-dimensional designer, is being able to take those designs and make them move--animate them. In print, you can still layer inks, push things back and pull things forward, but in interactive, objects can move in space and time.
> —Neil Powell

the best people possible."

Joe Duffy, founder of Duffy Design and creative director of Duffy Design Interactive, is an industry veteran who brings considerable marketing expertise to his firm's newest venture. "What I love about surfing the Net is it takes me back to when we started Duffy Design in 1984," Duffy recalls. "We were criticized at the time for our design work being too complex and too layered." Duffy views his layered approach as an asset in Web design. "I've always believed in communicating in layers with the audience. To attract their attention first, to come across with something that makes them snap their head back and think to themselves, 'I want to look further.' Then one begins to communicate on another level, and then the viewer can choose another level, and so on and so on, depending upon the level of interest."

Welcome to the world of Tidy Cat →

Please meet our charming and (usually) lovable threesome--Cinammon Nigel and Ms. Frosty.

Pick your favorite resident cat to guide you through the site.

Index Search Guestbook Choose a Cat

Hi! I'm Cinnamon, here to cuddle, pet or just plain follow you around the new Tidy Cat site. There's so much to do and see! Want to have some fun? Let's go to Catnip Corner.

TIDY CAT

Welcome to Tidy Cat!

1. Cat's Facts
2. Cat Care Central
3. Cat Box Filler 101
4. Catnip Corner
5. Feline Forum

www.tidycat.com

The Tidy Cat site is one of several sites Duffy Design Interactive designed for Purina, including purina.com, the umbrella site for Purina's various products. All of the Purina sites emphasize the joy of pet ownership through animation, playful illustration and type treatment.

The Tidy Cat site opens with an animated sequence. Headline typography is scrawled in a typeface that looks like a cat might have scratched it onto the screen. The viewer is then engaged by three cats who introduce themselves and offer to guide the viewer on a tour of the site. After a viewer selects a "tour guide," the Tidy Cat sales message is delivered—from a cat's point of view—as a means of educating cat owners on the benefits of Tidy Cat litter.

Prior to the formation of Duffy Design Interactive, Powell recalls what it was like to produce Web projects. "We just did it," he admits. "We had some guys who knew a little about the Internet and we started getting a few requests from some of Fallon's clients to design some Web sites. Little by little, we started getting into it more." Gradually, Powell and his team began to realize that the Web was becoming more than a novelty, and began to see its marketing potential. "It was changing the way we communicate with each other and we saw that it would ultimately change the way we do business," he relates. "We started investing in technology, investing in personnel, and tried to figure out how we could make this a useful tool for our clients. It was very difficult."

Since then, new media projects have been easier to manage. "Although I'm still not well-versed in the world of Web design, I have people who are," says Powell. "We rely on each other's strengths." Duffy Design Interactive is staffed with technical specialists who are willing to push the envelope. "What's great about Duffy Design Interactive is that we've got people who are never satisfied and aren't willing to take the easy road, either creatively or technologically," says Powell.

Powell describes the firm's approach to building a site: "Before we begin, we want to understand the company and its message," he states. "Then we build a schematic. The schematic is designed by the writers, designers and programmers together. At this point, the designer begins to think about the way the viewer will move through the site and about the navigation from an aesthetic standpoint, but most of the design happens after the navigation is figured out."

Information designers determine the hierarchy and organization of the site. "They take a lot of information and convey it simply for the audience," says Powell. "They have both writing and

organizational skills and work with the designer to make sure the information is being conveyed as directly and simply as possible." The writers might work for either Fallon McElligott or Duffy Design and have usually worked on previous advertising campaigns for the client. "This helps because that writer knows the personality of the brand."

Powell points out that programmers bring crucial skills to Web site development. "If you don't have good programmers, it doesn't matter what kind of idea you come up with, you're going to be limited to what everyone else can do," he relates. "We're constantly looking to create new ways of doing things." When hiring a programmer, Powell looks for someone who is ready to meet that challenge. "We want someone who won't say, 'I don't think we can do that' or 'It'll take too long to figure that out,'" he states. "If that's what you're up against when working with a programmer, then it's hard to create anything that's special."

Duffy Design Interactive has experienced a fairly smooth transition into new media, in part, because its designers are well aware of a client's needs by working equally in print and interactive

www.nikon.com

The Nikon, Inc. site is both an extension of the Nikon brand identity and a road map for Nikon's diverse line of products. Duffy Design Interactive redesigned an earlier site incorporating changes suggested by consumers. Major changes were made in the site's navigation—critical information was brought to the top level. Headers and footers were standardized to provide a clear navigational path. All products were databased to make product updates fast and easy. New departmental home pages provide more room for product news and updates.

Duffy Design Interactive also developed a Gallery section that showcases images taken with Nikon instruments from the world's greatest photographers and scientists. New photography made the site brighter while reinforcing key brand attributes.

multimedia. According to Powell, designing for both media can be a juggling act. "We've found that once you're involved in an interactive project, you're immersed in it," he says. "We're still trying to have our designers do both and mix it up, but it gets difficult because of the complexity of developing a Web site." When two designers are working on the same brand but in different media, weekly meetings keep them updated on developments in the design of the brand identity and visual requirements. "We have weekly status meetings as well as weekly creative meetings where we review all of the latest creative development."

With a background in print design, Powell has found that working in new media challenges him to think differently. "What's really exciting,

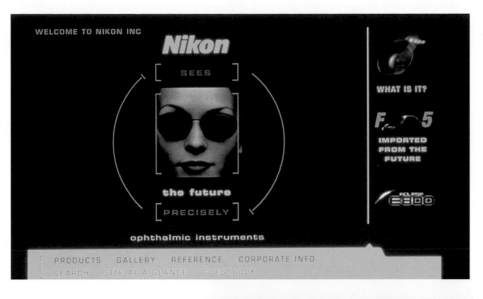

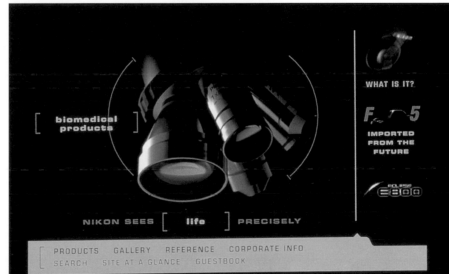

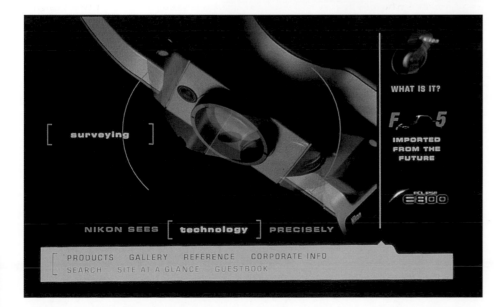

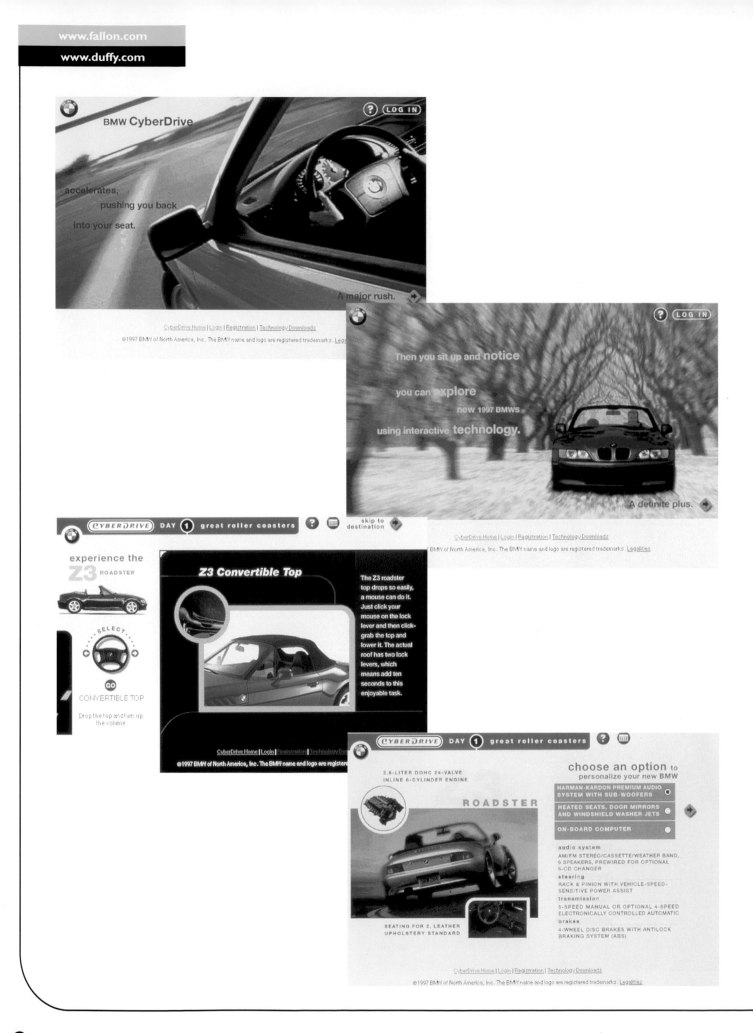

www.bmwcyberdrive.com

CyberDrive, a twenty-one-day event on the World Wide Web, was created to help promote bmwusa.com, BMW North America's Web site. CyberDrive linked customers with www.bmwusa.com with a CD-ROM that allowed them to access new information on each day of the event.

especially having been a traditional two-dimensional designer, is being able to take those designs and make them move—animate them. I'm now able to think in depth much more. In print, you can still layer inks, push things back and pull things forward, but in interactive, objects can move in space and time."

Powell also observes that a Web site design is a work in progress. "It almost becomes a living organism," he states. "It may never be completed or it can always change. That's a really cool thing because once you print a brochure, it's printed and you move on."

Powell says new media has proven exciting for Duffy Design Interactive clients, as well. "To have the ability to sell your product without the consumer having to go to a retail environment, and to have them experience the product almost as well as if they were in a retail setting is pretty exciting," he states. "The ability to pick a car, customize it with options, actually sit in the car, turn on the windshield wipers and hear the engines rev is pretty remarkable, and I think it's only going to get better."

case study 3

GALIE
JEAN-LOUIS,
MSNBC

Seattle

G alie Jean-Louis has always been regarded as an industry pioneer. She broke traditional design standards when she served as art director of the award-winning poster publication, *Impulse*, from 1992 to 1996. "Nothing had been done like this in the newspaper industry," recalls Galie Jean-Louis. "I was interested in establishing new ground in design for the newspaper industry and publishing."

Impulse was a weekly entertainment publication of the *Anchorage Daily News* conceived to increase demographics in the thirteen to twenty-two age range. "As a result of the publication, readership increased by 70 percent in the twenty to thirty age group," recalls Jean-Louis, now executive art director at MSNBC.

Design wasn't the only area in which Jean-Louis broke new ground with *Impulse* and her work for the *Anchorage Daily News*. "I was one of the first Apple purchasers in 1984, and was instrumental in taking the *Anchorage Daily News* into computerized production," says Jean-Louis.

Jean-Louis was again on the leading edge when, in 1991, she helped to get the *Anchorage Daily*

> I can't emphasize enough how new media will become integrated into our lives very quickly. It's not just a "Jetson" notion anymore.
> —Galie Jean-Louis

News on the Internet. "We were one of the first newspapers to take our paginations to online systems," she relates. "We took the whole paper online, including components of *Impulse*, news, features, and business, determining which sections held relevance to the user online versus in print."

Jean-Louis recalls what it was like to go online when there were no programs for building Web sites and few opportunities for learning how to build them. "In the beginning, we produced much of the development ourselves," she relates. "Since there were so few resources to draw upon, it was a matter of self-training." Jean-Louis learned how to write HTML code. "I believe the most powerful way to gain an understanding of navigation is to learn by doing and to immerse yourself in the actual technology, including HTML, programming and even Java," she relates. "When I learned code, I was able to then comp or sketch out possible

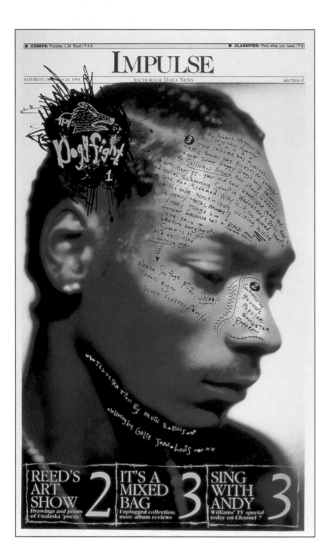

With Impulse, Jean-Louis was trying to attract a younger reader-
ship that wasn't responding to traditional print design standards.
Art director/designer: Galie Jean-Louis

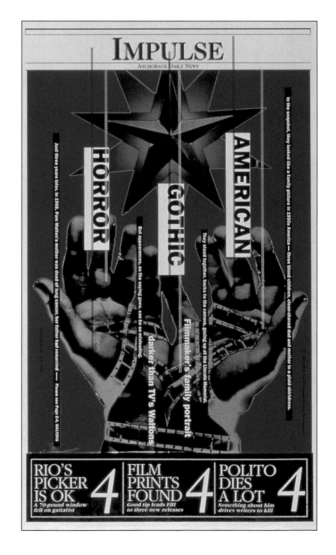

interfaces for taking the newspaper online."

While she was still working for the *Anchorage Daily News*, Jean-Louis's technical expertise led to freelance jobs helping others get online. Consulting on this level offered Jean-Louis an even greater understanding of online technologies and an opportunity to collaborate with clients interested in the Internet and new media.

When the World Wide Web started to attract the interest of the entertainment industry, Jean-Louis was in a good position to advance herself. She was hired by MSNBC in 1996 to work with a bicoastal team to redesign and art direct its Web site. The redesigned site offered interactive international and local news around the clock.

Since then, Jean-Louis has relied increasingly on others to supply expertise in areas beyond design. "Today online design is entirely collaborative," she relates." There is nothing singular

Published by the Anchorage Daily News, 8 Magazine *was created to compete with small, weekly entertainment magazines. The magazine's content included local arts and entertainment, book, food and restaurant reviews.*
Art director/designer: *Galie Jean-Louis*

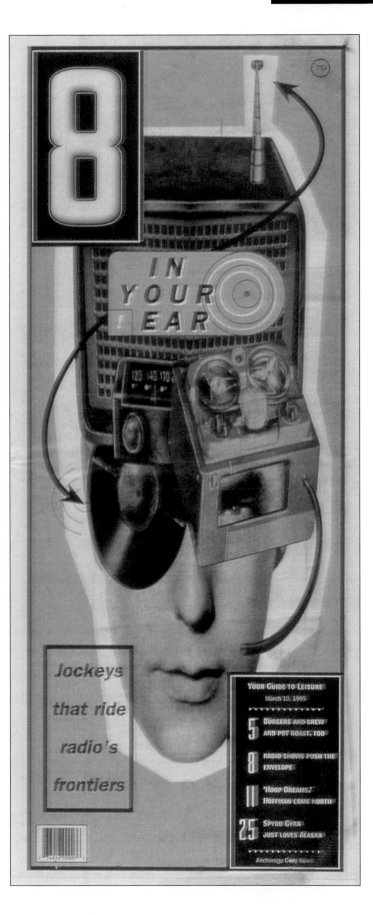

www.msnbc.com

MSNBC.com launched its redesigned news site on August 15, 1998. Designed by a bicoastal team of art directors and designers that included MSNBC staff and The Interactive Bureau, the new site combines the best interactivity on the Web with TV/on-air content for one of the Web's most successful and relevant news sites.

To better involve viewers in a host of ways, the new site features an entirely new look and structure, shifting from a vertical, scrolling screen to an enhanced easy-to-use 640 x 480 design. Navigation is further enhanced by a new cascading menu system that provides a comprehensive look at the day's news. Each main section is expanded with new content and interactive multimedia features that give stories a greater level of depth.

Creative director: *John Lyle Sanford*

Executive art director: *Galie Jean-Louis*

Art directors: *Denise Trabona, Greg Harris*

Design: *Sofia Vecchio, Paul Segner, Kim Carney, Chris Cox, Clay Frost, Jeremy Salyer, Bobby Steven*

The Interactive Bureau: *Roger Black, John Schmitz, Theo Fels, Johnathan Corum, staff designers*

about what I do." Jean-Louis compares herself to a film-maker, choreographer or director who works with a team of professionals. "We've moved from a learn-by-doing process to a sophisticated, streamlined team focus," says Jean-Louis.

This arrangement has relieved Jean-Louis of much of the technical work she used to take on and has given her increased control over the creative end. "I'm now designing and directing those teams and have the ability to bring together unique teams and talent for each

Tips

1 Make news fast and accessible. File size matters. Make sure graphics are under 10K and interactives are under 30K.

2 Storyboard and site map. Draw! Use the most important tools—your pencil and your mind.

3 Less is more. Design information that works as an interactive graphic only if the content merits it.

4 Stay current when working with news and technology. Users want up-to-the-minute information and tools.

5 Let design drive technology, not technology drive design.

6 Web site development requires that designers, editors, producers, technology/development staff, media, advertising and marketing staff all work together.

7 Test the page or interactive application prior to publishing.

8 Most important: Have fun. Embrace new ideas while pushing yourself, content and the limits of technology.

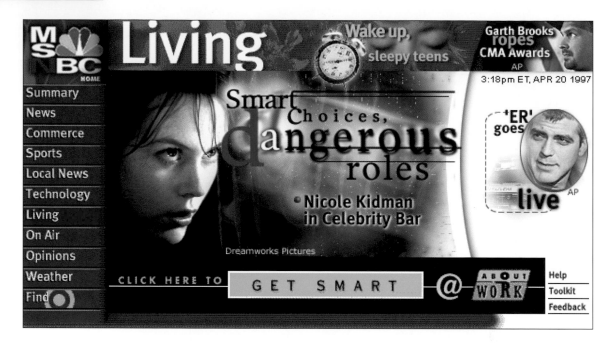

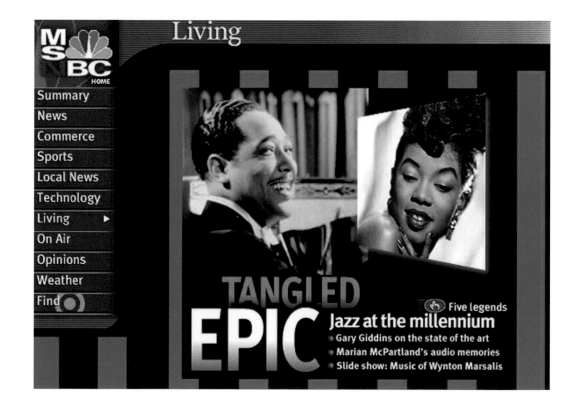

MSNBC Interactive "Living/Travel"
Entertainment Section

The "Living" section is published twice a week, with living and travel coverage alternating every fourth day. The section focuses on celebrities, fitness, travel and lifestyle content. Often the works of well-known photographers, illustrators, animators and Web designers are showcased in this section. Interactive slide shows, video galleries and chat rooms promote user participation on all levels of the section design.

project—a specific programmer, animator, illustrator or editor," she relates. "Sometimes we will streamline a team down to three people or we may have a team of thirty people working on both coasts."

A typical project for Jean-Louis can have a turnaround time of anywhere from twenty minutes to three weeks. She works with MSNBC creative director John Sanford and a team of editors and television producers to plan the project's production, scope and purpose. "We then strategize and confirm the team's size, structure and depth. Then, together we address design and interactive issues such as the need for various media types, templates, interactive features such as calculators, surround video or custom applications based on the story content," says Jean-Louis.

Jean-Louis believes that designers need to bring the graphic sensibility and vernacular back to the development of new media. "We need to bring the drawing, the storyboarding, the sequential nature back to it," she states. She also sees the role of the graphic designer

expanding in the near future. "Currently, we are in a very technology-driven time versus design-driven time. I see that changing," she states. "It's a notion that we're coming full circle. As we become homogenized through a global medium and marketplace, our graphic iconography must carry a ubiquitous equity."

Jean-Louis is at a point in her career where she is integrating various types of media strategies into her design solutions. "What I'm interested in is publishing simultaneously in a converged product of television, the Net and print," she explains. "These three areas have become so expansive that now we can start to work at finding delivery platforms using all the tools we have. To me it's the most satisfactory marriage."

Regarding the Internet and its future, Jean-Louis says we've just seen the tip of the iceberg. "I can't emphasize enough how new media will become integrated into our lives very quickly. It's not just a 'Jetson' notion anymore." Jean-Louis predicts that the art director of the future will play an increasingly important role in how the Internet will affect our lives. "Art directors

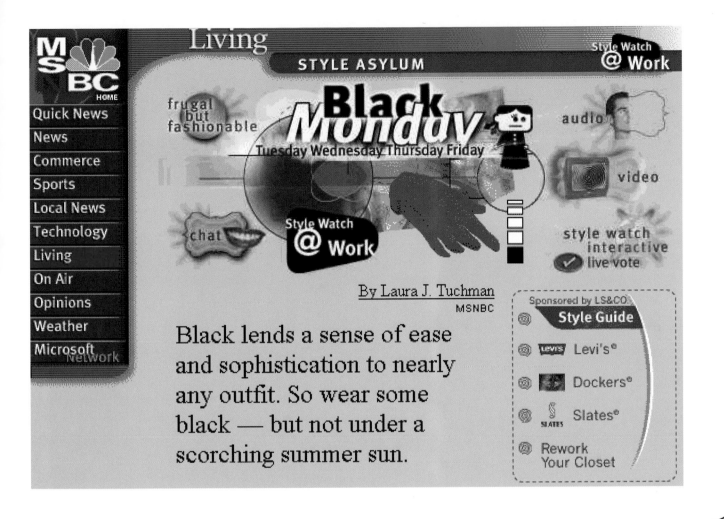

and designers will play vital roles in how we use seamlessly integrated interactive design in all areas of our lives—not just computers. Online design will be integrated into our homes, TVs, cars, hospitals and banks."

MSNBC "Style Asylum" Section

This section focuses on the latest fashion news. Among the features it offers are interactives, videos and chats with fashion celebrities. This section also shows the latest runway styles by offering up-to-the-minute catwalk slide shows from around the world.

case
study 4

SAYLES

GRAPHIC

DESIGN

Des Moines

John Sayles and Sheree Clark

Sayles Graphic Design entered the arena of computer-aided design relatively late, in 1995. "Before we purchased our first computer, I did a tremendous amount of research and talking with staff, other designers and competitors to determine the best computer for our situation," explains Clark. "Now we are approaching our interactive projects in much the same way—lots of research and lots of caution."

Firm principal John Sayles notes the many changes his firm and the design business in general have experienced since Sayles and Clark founded Sayles Graphic Design in 1985. "We started our firm with nothing and did pro bono work for non-profits," he relates. "Little by little, our reputation grew and clients started coming to us for the unique look and service we offered. A lot has changed since we started. The computer gradually took the place of the 'old way' of doing things."

Sayles and Clark were recently asked by a client to design a Web site, and were hesitant at first. "Having no direct experience in this area, we weren't certain we wanted to be responsible

When it comes to technology, there are different kinds of people. There are those who embrace the newest, best and funkiest that money can buy. Then there are those who wait to see what really works, what is going to last and what is the best investment. We fall into the second group and that has been our philosophy regarding equipment/computer purchases all along.
—Sheree Clark

for this type of project," says Sayles. "Our decision to move ahead was influenced by the fact that some of our clients who had sought Web design services from other companies ended up with less than satisfactory results. Their Web pages did not live up to the collateral image we had developed for them. Even though we supplied images—photos, graphics, etc.—for the Web designers to use, they were unable to achieve the design quality our clients were accustomed to."

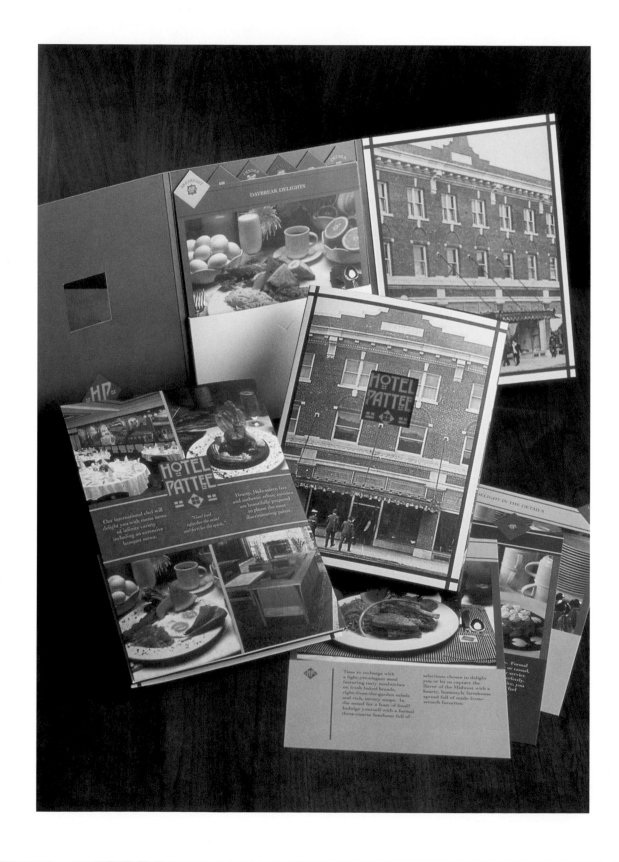

Printed projects Sayles had designed, such as the Hotel Pattee's banquet folder, projected the image the firm needed to re-create for the hotel's Web site.
Art director: *John Sayles*

Sayles finally agreed to get involved in developing a Web site for the Hotel Pattee, a client of two years. The Hotel Pattee wanted to establish a sense of ambiance with its Web site—a feat Sayles had accomplished with the printed materials he had designed for them. Sayles and Clark had to determine how to proceed. They decided collaboration was the best solution for them. "We told the Hotel Pattee that we would oversee their Web page development, and we set out to find a partner. Sheree is the 'smart' side of our partnership," says Sayles. "She takes care of the business end and working with the clients. It was natural that she become the point person on this project."

Clark met with a number of development companies of varying size and experience levels. "I had prepared a list, with the client, of what the Web site should include, so that we could base our estimate on the complexity of the content and navigation of the site," says Clark.

"Ultimately, we selected Court Avenue Net-

works because of their professionalism and our comfort level with the designer we would be working with."

After a meeting with Court Avenue to discuss a plan for the Hotel Pattee site, the Web site development company suggested some additions that Clark hadn't thought of, and they began to further define the content of the site. A Court Avenue representative then met with

Tips

①
When searching for a Web site development firm, try to visit the facility where the work is created. This will help you get a sense of the level of professionalism of the staff as well as the stability of the company.

②
Try to meet the actual Web designer to ensure there is a personality and style "fit."

③
Ask the development company to show sites they like but didn't create themselves. This will tell you where their taste and sophistication level is without the constraints of client direction.

④
Ask how updates to the site will be handled. Ask in advance about fees for updates and how long the updates take.

⑤
Request and check client references. Did past clients receive a good value for their dollar? What response did their site generate?

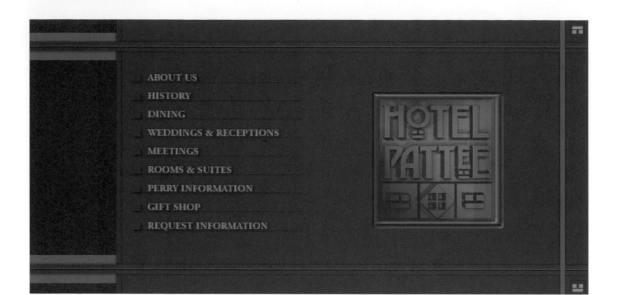

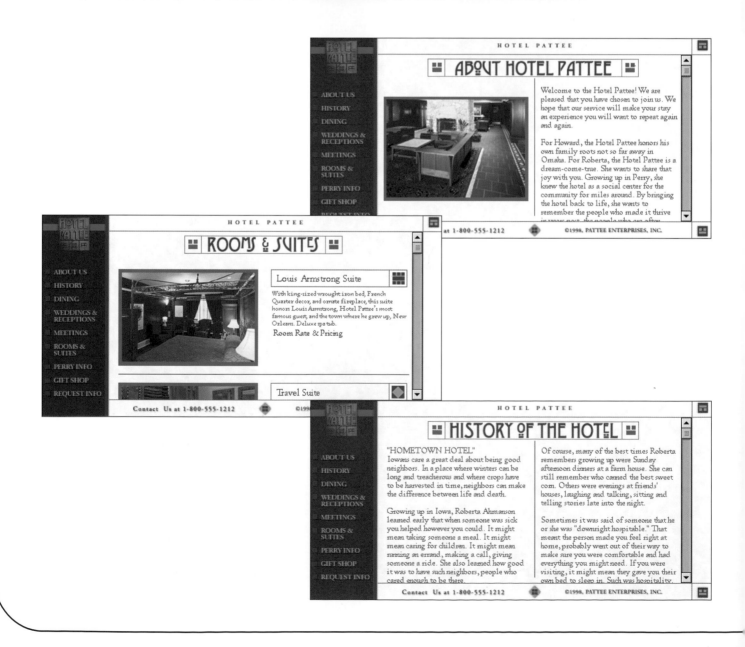

www.hotelpattee.com
Sayles developed a look for the Hotel Pattee Web site that reflects the hotel's Arts and Crafts-era architecture. Sayles also gave viewers a sense of the hotel interior's rich colors and textures—not easily conveyed in an electronic format. In addition to the hotel's history and banquet, meeting and rate information, the site includes photos and descriptions of each of the hotel's forty rooms and suites and allows guests to "browse" through the hotel. The "welcome letter" from the hotel's owners is the same letter that is placed in each room upon check-in.
Art director: *John Sayles*
Technician: *Brandon Cronk*

the Hotel Pattee to further refine the site's content as well as the image it would project. "Once the look and feel of the Web site was established, we determined final content and copy," says Clark. "My challenge was to keep our client from adding too much copy."

When getting involved in developing the visuals that would comprise the site, Sayles realized that he needed to design more than what was represented in his client's printed materials. "The site had to interact with the person reviewing it," says Sayles. "Every room is custom-designed around a specific theme. We needed to communicate that on the Web site. It had to have its own life, its own personality. We couldn't just take what we did in print and translate it to the Web."

Sayles encountered a number of challenges when translating the look of the hotel's print collateral into the Web site. Among them was "the leather look we use in some print applications," says Sayles. "It didn't look good on screen."

Sayles Design has arranged for Court Avenue Networks to revise the Web site as needed. Says Clark, "Most of the updates will be seasonal in nature, such as menu items, etc. We designed the site so that when there were changes, such as room rate changes, they were limited to one area of the site." In the case of the Hotel Pattee site, this meant including a rates page rather than listing individual rates on individual room pages. Sayles Design may have to deal with some changes to the site, such as special packages, during slow seasons. "We're trying to make it turnkey so that Court Avenue and the hotel can work directly together without us for routine changes or price changes," she states. "We've been very upfront with the hotel by saying, 'We're bringing something to this project by being here. When you're just changing prices, all we add is cost and time.'"

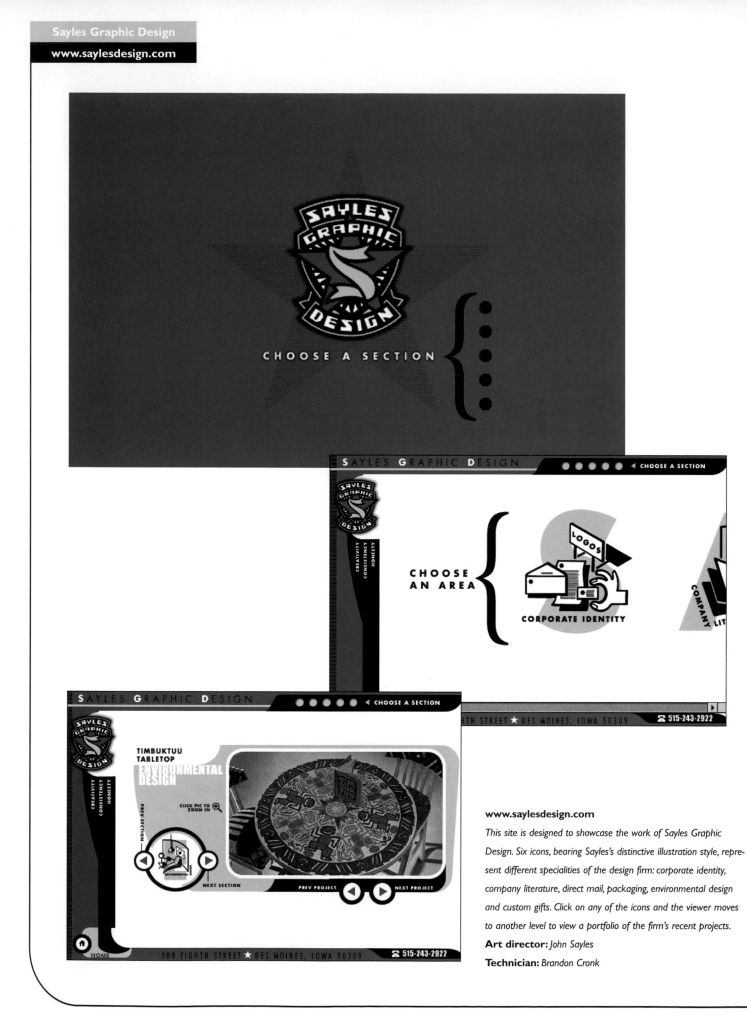

www.saylesdesign.com

This site is designed to showcase the work of Sayles Graphic Design. Six icons, bearing Sayles's distinctive illustration style, represent different specialities of the design firm: corporate identity, company literature, direct mail, packaging, environmental design and custom gifts. Click on any of the icons and the viewer moves to another level to view a portfolio of the firm's recent projects.

Art director: *John Sayles*

Technician: *Brandon Cronk*

Working With a Codewriter

- Whenever possible, give the site developer hard copies of existing print collateral. Also provide a graphics standards manual and any other background materials available.

- Have weekly meetings to keep the process on track.

- Be sure to have final, approved copy before you begin development. It can get costly to edit at this stage.

- Help manage costs by providing scans to the developer. In most cases, these can be the same scans used in printed pieces.

However, when they want to add a new page or new link, then we absolutely will be involved."

Both Sayles and Clark agree that the Hotel Pattee was the perfect client for their first foray into new media. "We were fortunate because this client was perfect for this project," says Sayles. "The Web site was not our first project with the Hotel Pattee. We'd gotten them a lot of recognition through our print work. They trusted us, believed in us, and that gave us credibility. Trust is everything."

When they began research on the Hotel Pattee Web site, Sayles and Clark decided it was time to establish a presence for Sayles Graphic Design on the World Wide Web. "It's primarily presence and credibility as well as a vehicle to showcase our current work," says Clark. "Ten years ago, if you didn't have a fax, you weren't a real business. It's like that now with Web sites and e-mail."

Sayles is excited about his firm's recent plunge into new media. "Working with the different components of sound and movement opens up a new outlet for creativity," says Sayles. "It makes my graphics come alive."

Sayles envisions a future where Sayles Design is increasingly involved in new media. "As our company moves into the future, we'll be doing more producing and directing." Sayles likens the move into new media with other transitions he's made as a designer. "If I can design a printed menu, then I can design the glassware and dinnerware," he explains. "Why shouldn't I pick the sound and choreograph the images for a Web site?"

case study 5

NERVE, INC.

Cincinnati

Nerve, Inc. (formerly Siebert Design Associates) is a multifaceted company offering two- and three-dimensional communication design. The firm operates with a design staff of seven, plus financial and marketing support staff. Prior to becoming involved in new media, the firm's work included corporate identity systems, print, packaging, environmental graphics, signage and illustration.

Nerve, Inc. *From left to right: Ben Meyers, Alan Hopfensperger, Molly Zakrajsek, Steve Siebert, Diann Shumaker, Sarah Harrison, Lori Siebert, Nick Gliebe.*

Nerve, Inc. is slowly making the move into new media. "There has never really been a good time for training," says Gliebe. "Rather than stop everyday print and signage work, we have tried to fit in a few small Web site projects to get our feet wet. This strategy, of course, has involved learning from small mistakes along the way."

At Nerve, Inc., new media has not really altered the firm so much as it has crept in and nestled into it. "Designing an identity, for example, now has interactive implications," says Gliebe. "The digital branding and potential for a logo in the interactive realm needs to go beyond how it looks in print, on a fax or on a large sign. We now need to take into consideration how the logo moves, sounds, or appears in color at a lower resolution on a monitor."

> There was no real defining moment when we first became aware of new media. It came to us gradually.
> —Nick Gliebe

Nerve, Inc. has elected to focus on design and partner with consultants for technological and developmental support. Says Gliebe, "Our staff is still design-based. We have formed alliances with some local programmers who make it all work." Working with a broad range of technicians has allowed Gliebe to assess the type of site programmers that collaborate best with Nerve, Inc. "These technicians can be very different in their skill and technique, yet as pragmatic as any designer, illustrator or photographer," Gliebe relates. "Some offer great and unsolicited ideas, are brilliant, creative and reckless. Others are afraid to push the envelope—they adhere to very safe Web principles. The key is to pick the technician that is right for the client and the budget."

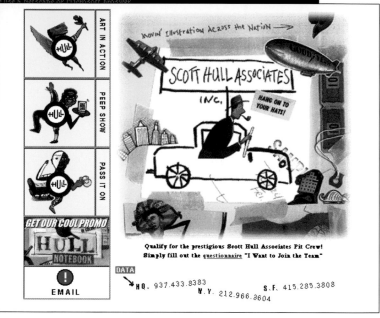

www.scotthull.com

The purpose of this site is to create an online resource for designers to search for and hire artists represented by Scott Hull Associates. The site not only showcases the illustrators' work, but contains an advice section with industry tips for designers and illustrators.

Art director/designer: *Nick Gliebe*

Copywriters: *Scott Hull, Laurel Harper*

Technician: *Joe Siegmann*

When selecting a programmer, Gliebe recommends asking lots of questions. "I have discovered the programmers we work with through word-of-mouth," he relates. "Somebody always knows someone who's really up to speed with a new programming language. If the client hasn't requested a specific programmer or development company, we will interview candidates and have them show us sites and interactive work they've done, and then have them describe their working process. This assures us they know more about the technology than we do."

With clients such as Nickelodeon, Universal Studios, the City of Cincinnati and *HOW* magazine, Nerve, Inc. has developed a reputation for its innovative design solutions. Gliebe says new media offers the firm's designers a new outlet

ART IN ACTION

Click one of the titles below to be truly enlightened.

A TOY STORY

STONY FRIENDS

THE ARTIST
AND THE ATHLETE

HOT WEB SITES

SCOTT HULL
HOME

PEEP SHOW

PASS IT ON

GET OUR COOL PROMO
HULL
NOTEBOOK

EMAIL

DATA
HQ. 937.433.8383
N.Y. 212.966.3604
S.F.

THE ARTIST
AND THE ATHLETE

PREVIOUS NEXT BACK HOME

Olympic Gold Medal gymnast Shannon Miller was having difficulty with her technique. Luckily, illustrator Andrea Eberbach was there to assist. Now Andrea wasn't trying to advise Shannon regarding her vaults or beam flips; Coach Bela Karolyi was more than capable in that arena. But for the children in war-torn countries who count on UNICEF funding to help them survive, Andrea's assistance was much more important. She was helping Shannon create art for a T-shirt for the Olympic Aid Auction, sponsored by Hanes International. The money raised would be donated to this worthy UNICEF program.

The Indianapolis-based illustrator was one of 12 artists paired with Olympic athletes to design the shirts. While the original assignment called for the athletes alone to create the art, in the end Hanes decided they might just need a little assistance from the pros. Shannon's idea [a gymnast leaping over a globe] wasn't that bad, Andrea says of her partner's attempt at illustration. I just needed to take the basic concept and develop it.

Andrea, who likes to work with paper cut-outs, has a proclivity for strong, bold colors and one-dimensional, geometric shapes. This style proved perfect for adorning a shirt. The result was a striking, bright Tee that proved very
Some might think dealing with a teenage celebrity could be trying, but Andrea found Shannon as
gymnast makes tumbling look.

PEEP SHOW

Click on a tile below to see more of that artist's work

Dave Albers	David Beck	David Bowers	Tracy Britt	Andy Buttram
John Ceballos	Greg Dearth	Helen Dsouza	Andrea Eberbach	Douglas Fryer

Tips

1

Take the time to learn from people you respect. If you don't know any good sources, find them. They are everywhere.

2

Spend money on training. Teaching yourself is hard and information tends to get left out.

3

Hire energetic people right out of college. They've just had valuable training paid for by someone else.

4

Be selective when hiring a programmer. Try to match the capability level and temperament of the programmer with the project's needs.

for creative energy. "We're forced to look at more facets of communication than in the past." Gliebe notes that it's a creative challenge to be able to navigate a viewer through a series of choices with which they feel comfortable. They need to be stimulated but not overwhelmed by what they're confronted with. "Speed, timing and originality weigh heavily on viewer impression," adds Gliebe.

When Nerve, Inc. gets involved in a Web site project, they first meet with the client to determine what the site's objective is. Gliebe says he and his staff tackle many questions at this point: "How many levels are really necessary to convey what needs to be said? How much text is enough to communicate clearly?"

After information is edited and divided up into logical "chunks," a navigational map is created. This map outlines the hierarchy of the site's content and how it will link together. The navigational map also helps Nerve, Inc. keep track of what's been completed and what needs work. "It also makes it easy for the client to see and understand the scope of what they are paying for."

Gliebe says design seems to be a natural "next step" at this point. "We ask ourselves, 'Do we need more or fewer graphic elements in the site? Are there enough visual cues to let viewers know where they need to go next, as well as where they've been?'" he says. "I am an avid user of the Internet, so it is easy for me to pinpoint what I believe feels comfortable in a site, as well as what is really unnerving," says Gliebe.

"Because the result is not linear as in a typical print piece, content seems to flow more freely and always finds a place to rest in the site," he states. "You can always add more links and make them as evident or hidden as you wish. Because of the nature of the Web, you can build a working version of the site and add on to it at any time."

Gliebe's advice to other design firms contemplating a move into new media is to look for capable people currently involved who can offer advice and expertise. Gliebe also says that designers shouldn't procrastinate about getting involved in new media, or they'll be left behind. "Don't wait; dive in now," says Gliebe. "This applies to any new endeavor, but it couldn't be truer than now. You'll have more fun than you think."

www.soundimages.com

This site was the first online presence for Sound Images, a company that provides high-end total audio production. As often happens with new sites, this project began with overambitious objectives and an unrealistic schedule that nearly crippled the project. After much rethinking on the part of Sound Images, content was limited to a description of who they are, some samples of their music and an image of the actual recording facilities. The site design is currently moving to the next level of development and may feature FLASH animation. Browser hits in each area of the site are being monitored to determine their worth and their importance to potential customers.

Art director: *Nick Gliebe*

Copywriter: *Charlaine Martin*

Technician: *De Stewart*

case

study 6

TURKEL

SCHWARTZ &

PARTNERS

Coconut Grove

Turkel Schwartz & Partners

Bruce Turkel of Turkel Schwartz & Partners has been successful in transitioning his firm from traditional print projects to interactive multimedia. He feels his firm's involvement in new media is a reflection of the way the new media is changing the design industry in general. "In the past we were essentially producing artwork the way it's been produced for hundreds of years. Only the photographic processes had changed," explains Turkel. "Now we try to incorporate new media into everything we do—even traditional print projects." As an example, Turkel cites his firm's client presentations, which are often in a new media format. "While the actual magazine ad or corporate ID program may not use interactive technologies, we still make the presentation available to them over the Web and on disk," he states.

Turkel first got involved in computerized design shortly after founding his firm in the mid-1980s when a bout with pneumonia afforded him an opportunity to get well-acquainted with the Macintosh. "My doctor's prescription was an impossible two weeks in bed," he relates. "A

> New media has changed everything we do.
> It's really been a complete paradigm shift
> in our agency and the industry.
> —Bruce Turkel

friend of mine had bought a Macintosh 128, and I spent the next two weeks learning how to use it. I got so excited by the technology's potential." Turkel's newfound expertise led to producing projects on the computer prior to the advent of page layout programs and before most design firms had become involved in digital production. "Our first computerized project was a newsletter for the University of Miami, which we clumsily created in MacPaint," recalls Turkel.

In 1995, Turkel's agency joined forces with Schwartz & Kaplan Advertising to form Turkel Schwartz & Partners, a forty-two-person advertising agency. "Since the 1980s, computer

intro

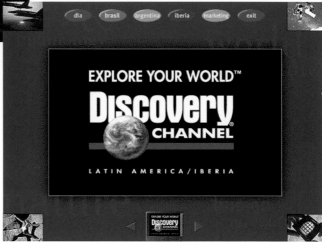

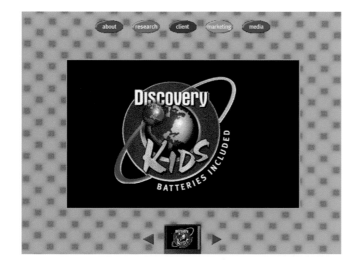

Discovery Channel Interactive Sales Presentation
This interactive advertising sales presentation on CD-ROM can be easily customized by the Discovery Channel's sales team to sell ad time to prospective clients. After watching a two-minute multimedia show, the presenter can pick which of the Discovery signal products he wants by clicking on the appropriate screen (Discovery Channel, Discovery Kids, Animal Planet or People & Arts) and then travel throughout the various channels. Turkel Schwartz also designed an elaborate sales brochure that is given to prospective ad buyers as a leave-behind.
Designers: *Rebecca Carlson, Alexandra Trinanes, Rand Hill*
Copywriters: *Dan Gronning, Mike Calienes*
Chief technologist: *Rand Hill*
Creative director: *Kirk Kaplan*

technology and now new media have become a part of the fabric of what we do," says Turkel. He admits that the impact of new media has been a challenge for the agency. "We've had to change many of our management practices to deal with all of it," he states. "We now have an enormous investment in computers and equipment." Turkel notes that new jobs had to be created for people who manage the equipment used for new media projects and that these individuals need to keep up to date and on the leading edge of marketing and communications technology. "Most importantly, we have had to make sure that we are able to amortize our costs over shorter and shorter periods of time," says Turkel. "We are constantly having to

feed the monster: upgrade our hardware, software and our people."

The shift into new media has also required some changes in the way the firm approaches projects. "We've not only changed the way we work—we've also changed the way we think," he explains. "All projects that have a new media component have to be created with an interactive mindset because we often will combine motion and music with all of the aesthetic considerations we deal with on any project."

According to Roberto Schaps, Turkel Schwartz's managing director, the move into new media is just beginning to pay off. "It's not just about the capital investments made, but also the time

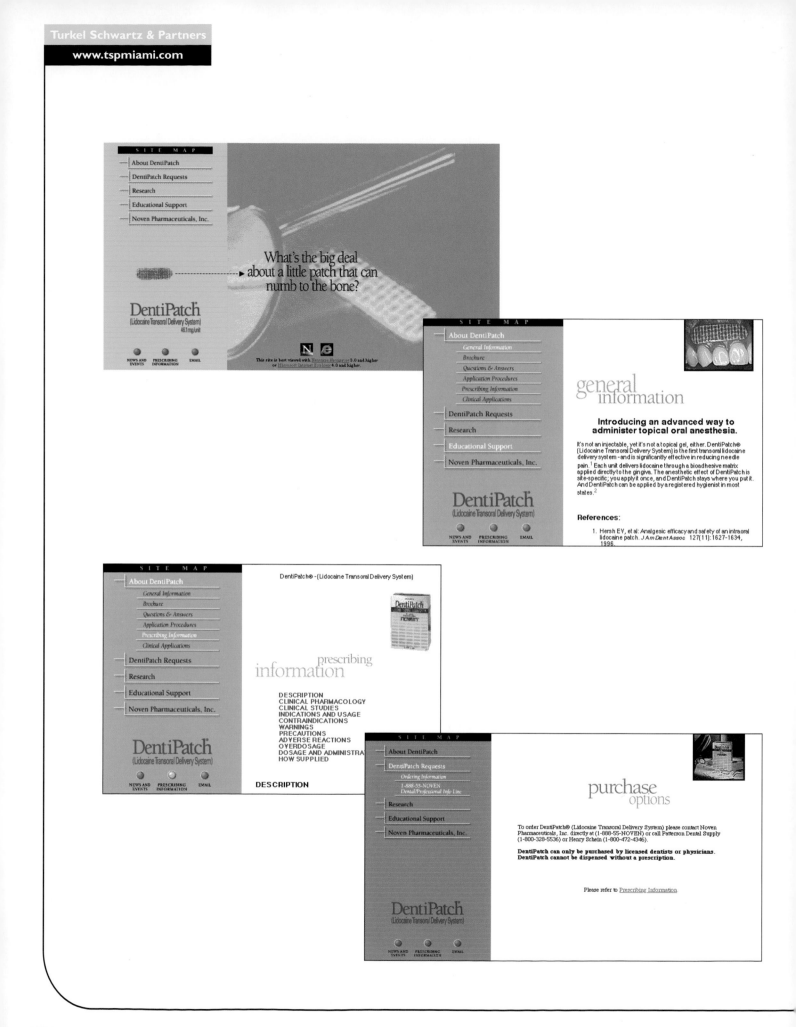

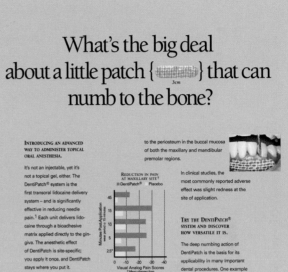

(Above) www.dentipatch.com

This Web site helped Noven Pharmaceuticals introduce DentiPatch—a new product that painlessly delivers lidocane to patients—to dental professionals. The site also trains them in its use and application. The site is supported by a direct mail marketing campaign as well as by magazine ads (above) that entice dentists and hygienists to interact with Noven. Turkel Schwartz also created a promotional and training video that was sent to dental professionals who requested it.

Designer: *Janice Davidson*

Copywriters: *Dann Gronning, Julie Ross*

Chief technologist: *Rand Hill, Louis DiCarro*

Creative director: *Kirk Kaplan*

Tips

1

Don't be afraid. Jump in feet—no—head first. If you wait until prices go down or technology matures, you'll be left behind.

2

New media should not be thought of as a foreign discipline. Think of new media as just another tactic or tool to solve your marketing challenges.

3

Educate your staff to know and understand new media. It's more than surfing the Web: It's understanding the implications, applications and relationships of new media to marketing.

4

Form a group of interested employees to keep up to date on developments in the industry and share the knowledge throughout the company. At Turkel Schwartz & Partners, we call this group our "Digital Task Force" and we meet regularly to share all they have learned.

5

Subscribe to as many industry publications as you can afford, and read them as often as you can.

6

Don't be afraid to let employees have access to the Internet and other new media.

7

Make new media part of the fabric of your company. Make it as mainstream as the fax machine and FedEx. Don't hide it—share it and show how it makes your company better.

8

Find a leader in your organization who is technologically aware and can introduce new technology into your future business plan.

required to learn the new technologies and apply them to our clients' needs," he explains. Computerization has really paid off in cost cutting. We are much more efficient than we were before, because we 'think' new media."

Although they are beginning to see a payoff now, this wasn't the case in the beginning, when the firm was hoping to quickly recoup its investment in new media equipment and training. "For a long time it was difficult to sell the idea of new media to our existing clients," says Schaps. "They didn't generally think of us to solve their new media problems even though we tried to show them why they needed a CD-ROM or Web site. We found that it wasn't until they had an external motivation, such as a competitor's new program or a new, savvy board of directors, that they would even consider new media. Then they would proudly show us what they had commissioned from a different development company and often were surprised when we reminded them that we had the expertise to do the same work."

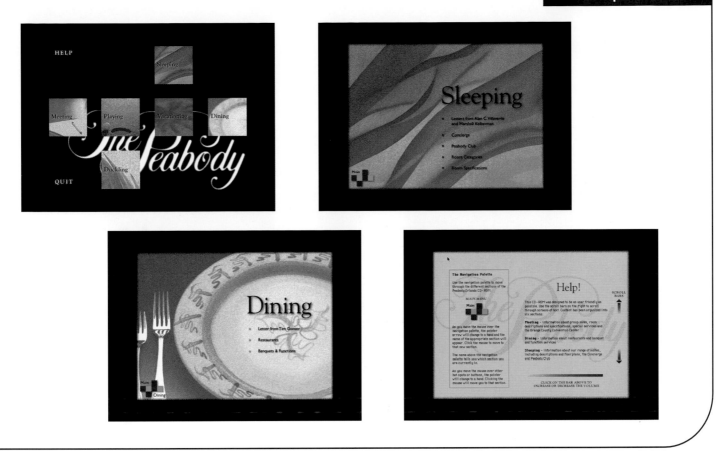

Peabody Orlando Interactive Sales Presentation

*This interactive CD-ROM presentation was created to give profes-
sional meeting planners all the information required to book a con-
vention at the Peabody Hotel. Users can take a virtual tour of the
property, watch video of the world-famous Peabody duck march
and even explore all of Orlando's attractions. The interactive inter-
face allows meeting planners to go as deep into Peabody property
as they need to—from viewing the basic information about the
guest rooms to checking out floor plans and seating arrangements
in each of the hotel's meeting and convention rooms.*

Designer: *Alexandra Trinanes*
Copywriter: *Dan Gronning, Mike Calienes*
Chief technologist: *Rand Hill*
Creative director: *Kirk Kaplan*

The Alabama Gulf Coast

COME
PLAY
IN OUR
BACKYARD.

GULF SHORES
ORANGE BEACH

ACCOMMODATIONS
LOCATION
THINGS TO DO
WRITER'S RESOURCES
GROUPS
OTHER ALABAMA SITES

GULF SHORES
ORANGE BEACH

The Alabama Gulf Coast - Come play in our backyard.

Once you've traveled just far enough,

you will come to a scenic hideaway

that offers the perfect mix of silence and peace.

Everything quiets. Nature speaks.

And gulls swing form and invisible thread in the sky.

They see you.

Motionless on the sand. Your eyes closed.

Breathing and dreaming.

Breathing and dreaming

Breathing and dreaming.

ACCOMMODATIONS
LOCATION
THINGS TO DO
WRITER'S RESOURCES

OTHER ALABAMA SITES

GULF SHORES
ORANGE BEACH

The Alabama Gulf Coast - Come play in our backyard.
MEETINGS TRAVEL AGENTS GROUP TOURS

BREATHING AND DREAMING
MAKES FOR A WONDERFUL GROUP EXPERIENCE

Gulf shores/ Orange Beach has been a most gracious host

to visitors from all over the world. Why do they come?

Most importantly: why do they come back? Choice

There are plenty of activities to bypass – or be a part of. Bike rides. Arcades.

A waterpark. A zoo. Mini–golf courses for children of all ages, as they say.

Long walks on the beach. Boutiques. Gift shops. Art Galleries. Specialty shops.

All within a mortar's throw from Fort Morgan.

ACCOMMODATIONS
LOCATION
THINGS TO DO
WRITER'S RESOURCES
GROUPS
OTHER ALABAMA SITES

GULF SHORES
ORANGE BEACH

The Alabama Gulf Coast - Come play in our backyard.
MAP WEATHER

HERE, ON ALABAMA'S GULF COAST
INVADING THOUGHTS DON'T STAY LONG

They are not welcome. Not here.

Our sugar-white shoreline boasts a 32-mile stretch of beach offering plenty of space

in which to dispose of plenty of thoughts.

From the south, emerald green waters crashes at your feet.

The waves' cool mist hovers, and a breeze caries it inland.

You peek out from under a lazy eyelid, catch site of the gulls,

and they depart as quickly and quietly as your thoughts.

Leaving you to your breathing and dreaming.

www.gulfshores.com

The Alabama Gulf Coast Convention & Visitor's Bureau benefited from Turkel Schwartz's multimedia approach to its promotion. The agency created print ads for newspapers and magazines, television commercials and an interactive Web site. A picket fence graphic, which appears on the site's home page and represents the serenity and quiet of the Gulf shores, is used on all marketing materials, including magazine ads (above). Users who enter the Web site can access a comprehensive database to learn more about area hotels and restaurants.

Designers: *Janice Davidson, Reneé Kuci*
Copywriters: *Mike Calienes, Kimberly Mattig*
Chief technologist: *Rand Hill*
Creative director: *Kirk Kaplan*

When asked about the quality of work produced by the other companies and how it worked for his clients, Turkel is circumspect. "Sometimes the design quality was good, sometimes it was not so good," he relates. "For the clients that respect what we do and understand it, poor results were reason enough to come back and ask us to take on their future digital projects. The clients who didn't really see any difference between what they were getting elsewhere and what they were getting from us were a harder sell. If we didn't think their design aesthetic could be raised or they were not willing to pay us both in time and money to do a better job then we simply didn't pursue their business very hard, if at all. Now," Turkel says, "new media is much more popular and the learning curve is less. Our clients look to us to solve their technology problems just as they look to us for solutions to their other, more traditional communications and marketing problems."

Costa Rica

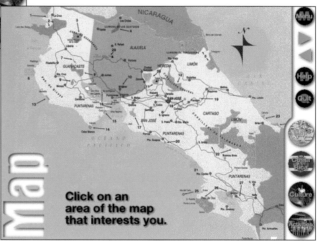

Map

Click on an area of the map that interests you.

Activities

The Northern Region

Page 1 of 5

On the other side of Lake Arenal, in the province of Alajuela, and 4 miles from wonderfully relaxing waters of Tabacón Spa, surrounded by rain forests, rivers and waterfalls.

Cuidad Quesada is about half-way between Lake Arenal and San José, heading through the agricultural and cattle ranching plains of San Carlos. Tourism activities are starting to develop in this part of the country, as well as nearby Sarapiquí, where some of the most interesting lowland rain forests flourish.

MIGHTY ARENAL VOLCANO AT NIGHT

A one-of-a-kind experience! There is no other tour like this one. Arenal Volcano is one of the most active volcanoes in the Americas. Its classic cone shape and constant activity, filling the sky with ash and red hot lava, will stun you from miles away.

Northern Region

Culture

TAM Travel Corporation
Interactive Sales Presentation

Produced for Costa Rica's largest travel agency, Tierra Aire y Mar (TAM), this interactive CD-ROM introduces the viewer to tourist activities in Costa Rica as well as some of TAM's tourist services. After a brief video introduction, the viewer can determine how to move through the presentation by choosing a heading of interest or clicking on various regions of the map. The entire presentation is nonlinear, which allows the viewer to move between interfaces as often as they like.

Designer: *Janice Davidson*
Chief technologist: *Rand Hill*
Creative director: *Kirk Kaplan*

Although new media has had a big impact on his firm, Turkel often falls back on his background as a print advertising designer when developing new media projects. "We've found that the traditional agency model of using a team of professionals to usher a project through works very well in the new media arena," he says. "For that reason, we assign each project a designer or art director, writer, account or business manager and a new media designer. The business manager will debrief the client, prepare strategy statements and preside over the turnover meeting with the creative team. This arrangement helps us to do the projects properly from both a marketing and technological viewpoint."

To aid the navigation development, Turkel Schwartz & Partners uses MacOrg, an interactive program that allows them to produce a giant flow chart of all of the pages or screens and instructions on how to access them. "For presentations, we usually tile together a room-sized chart and hang it in our conference room," says Turkel. "Then we invite the client to our office and take them on a paper-based virtual tour of their site or CD-ROM, following all the various links. Using brightly colored yarn and thumbtacks, we then create whatever additional bridges, links or paths we need. We create additional pages using yellow and pink sticky notes." After they've put the final navigation process together, Turkel

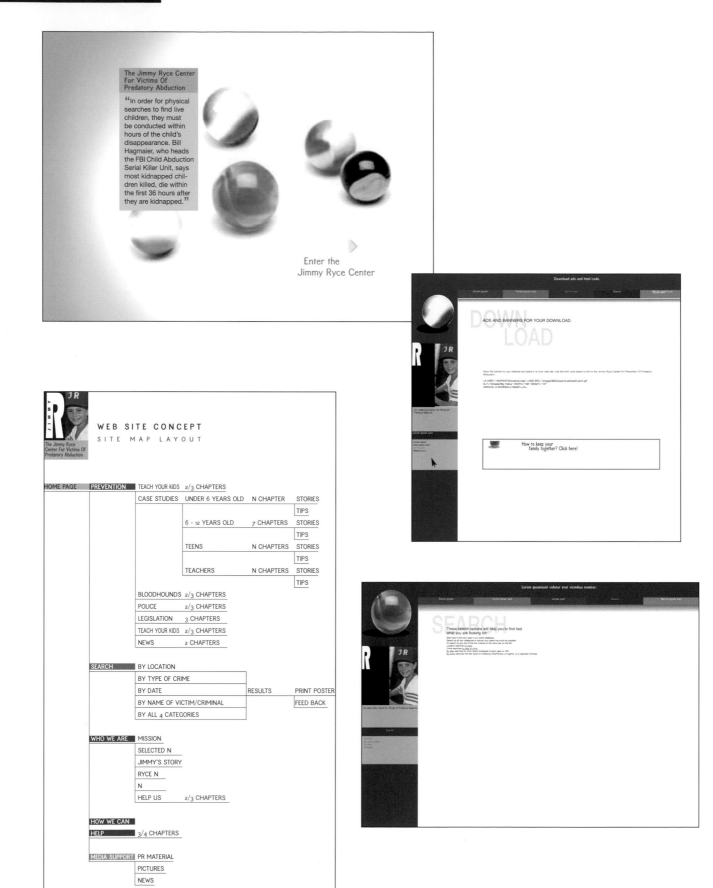

The Jimmy Ryce Center
For Victims Of
Predatory Abduction

"In order for physical searches to find live children, they must be conducted within hours of the child's disappearance. Bill Hagmaier, who heads the FBI Child Abduction Serial Killer Unit, says most kidnapped children killed, die within the first 36 hours after they are kidnapped."

Enter the
Jimmy Ryce Center

Download ads and html code.

ADS AND BANNERS FOR YOUR DOWNLOAD.

DOWN
LOAD

How to keep your
family together? Click here!

WEB SITE CONCEPT
SITE MAP LAYOUT

The Jimmy Ryce
Center For Victims Of
Predatory Abduction

HOME PAGE	PREVENTION	TEACH YOUR KIDS	2/3 CHAPTERS		
		CASE STUDIES	UNDER 6 YEARS OLD	N CHAPTER	STORIES
					TIPS
			6 - 12 YEARS OLD	7 CHAPTERS	STORIES
					TIPS
			TEENS	N CHAPTERS	STORIES
					TIPS
			TEACHERS	N CHAPTERS	STORIES
					TIPS
		BLOODHOUNDS	2/3 CHAPTERS		
		POLICE	2/3 CHAPTERS		
		LEGISLATION	3 CHAPTERS		
		TEACH YOUR KIDS	2/3 CHAPTERS		
		NEWS	2 CHAPTERS		
	SEARCH	BY LOCATION			
		BY TYPE OF CRIME			
		BY DATE		RESULTS	PRINT POSTER
		BY NAME OF VICTIM/CRIMINAL			FEED BACK
		BY ALL 4 CATEGORIES			
	WHO WE ARE	MISSION			
		SELECTED N			
		JIMMY'S STORY			
		RYCE N			
		N			
		HELP US	2/3 CHAPTERS		
	HOW WE CAN				
	HELP	3/4 CHAPTERS			
	MEDIA SUPPORT	PR MATERIAL			
		PICTURES			
		NEWS			

Lorem ipsumsunt videtur erat vicinibus moletur.

SEARCH

These search options will help you to find fast
what you are looking for:

www.tspmiami.com/ryce

Created as a pro bono project, this Web site was developed for the Jimmy Ryce Center for Victims of Predatory Abduction to assist parents and law enforcement agencies in disseminating information about missing children as quickly as possible. The universal reach and ability to instantaneously update this site helps make the critical goal of locating lost children a reality for many anxious parents.
Designer: *Herbert Reininger*
Chief technologists: *Rand Hill, Anjan Upadhya*
Creative director: *Kirk Kaplan*

Schwartz updates the MacOrg document, prints and tiles the pages, tacks them up and begins the process all over again.

For Turkel, whose duties include sharing new business pursuits with partner Philip Schwartz and creative direction with Kirk Kaplan, new media has provided an exciting new creative challenge. "New media has given me the opportunity to work in different media and figure out ways to apply new technology to standard marketing problems," he relates. In addition to providing creative input, Turkel also acts as client liaison and facilitator. "I'm not on the cutting edge of new technology, so I need to work with others who are better at code writing and software manipulation," he states. "But because I don't have all these skills, I am better able to explain it to our clients and lead them through what is, for them, a new and often intimidating process."

Turkel compares working with others who are more proficient than himself in their areas of expertise to experiences he's had jamming with a blues band during open mike nights, "Most of the musicians I play with are much better than I am and really know music theory and their way around their instruments. Still, I have a great time hacking around with them—I learn more about making music each time I sit in and I'm able to bring others into the fold because they figure if I can do it, anyone can!"

case

study 7

SEGURA,

INC.

Chicago

"We actually got into Web site design in 1995, before we really had any clients in new media," recalls Carlos Segura, principal and founder of Segura, Inc. "We'd always been on the cutting edge with the computer, so we were already developing interactive CD-ROMs to promote and distribute our own products before the Web became prominent." With the advent of the Web, Segura soon abandoned CD-ROM work. Says Segura, "The Web was cheaper and faster."

The work of Segura, Inc. reflects the unique aesthetic vision of Carlos Segura, who founded the firm in 1991. "I realized I was not happy creatively, so I started Segura, Inc. to pursue design with the goal of trying to blend as much 'fine art' into 'commercial art' as I could," he explains.

In 1994, Segura founded [T-26], a digital type foundry. "I wanted to explore the typographical side of the business," says Segura. "It was through developing interactive projects promoting [T-26] that our involvement with new media increased."

If we thought clients were uneducated as to what communication was about in print, then we just complicate the situation further when we throw new media into the mix.
—Carlos Segura

In order to maintain a creative atmosphere and stay selective in the projects his firm takes on, Segura has purposely limited Segura, Inc. to a small staff of seven. He concedes that putting a Web site together with a staff of this size can be challenging. "We have people on staff who design, write code and develop content," he explains. "What we don't have, we bring in depending on the project." Segura calls his firm a "boutique shop." Clients come to Segura, Inc. seeking the firm's unique brand of creative delivery. "Because of this and our size, the people we hire must have a better overall balance in regard to abilities," says Segura. "They're not just code writers, they're good designers as well."

Having started his career in print, Segura admits to a love-hate relationship with new media. "I absolutely love print. I still do print work and I actually enjoy doing print most," he admits. But Segura notes that new media has its benefits. As an example he cites the interactive aspects of

[T26] Type Foundry

These digital type catalogs, furnished to prospective customers
on CD-ROM and diskette, are programmed to run quickly on just
1MB RAM. For Macintosh only, they showcase the foundry's
typefaces within a unique, circular window.

Designer: *Jim Marcus*

Photography: *Jean Hillary, Daniel Givens*

his firm's Web site. "We have a private section for clients where we issue them a password so they can log on and check the progress of their projects, review layouts, make suggestions or follow along on a conference call," he says. "It has been a saviour many times. No more FedEx, attaching files to E-mail . . . no more lost packages. I love what Web sites can do, but I hate having to build them."

While Segura concedes that the nature of new media broadens his thinking, he admits that juggling all the balls can be frustrating. "I didn't get into the business to write code," he states. "That's not where my interest is. I think working on a Web site raises another layer of problems that designers have to deal with that they didn't have to deal with five years ago." Segura points out that with new media, the designer has to be much more than a designer. "When I first got into the business, there weren't any computers and it was my job to come in and think of ideas and design," he relates. "Now I have to think up the ideas, get the team together, worry about the code writing and the presentation. The responsibilities are increasing

www.t26font.com

Built with Macromedia FLASH 2 and 3, this Web site design relies on vector technology. The site contains complex tabulature that allows it to resize on any size screen. The Utilities/Type Glossary portion of the site includes a function where users can search for fonts by name. The Contact portion of the site lets users join the [T-26] mailing list.

Designer: *Jim Marcus*

Photography: *Jean Hillary, Daniel Givens*

and the work keeps piling up. There are so many things to consider. . . . It's wonderful, but at times it feels overwhelming."

Segura considers developing the content and navigation of the site one of the most difficult aspects of Web site development. "We are really involved in the development of the navigation," he states. "Most clients want to put as much up there as possible, and they definitely have a way of thinking about how they want to do it as well. Sometimes what the client envisions doesn't fit with the navigational aspects of the site. For us, the best way to present something is to simply show it to them."

In fact, educating the client on new media has been one of Segura's biggest challenges. "If we thought clients were uneducated as to what

communication was about in print, then we just complicate the situation further when we throw new media into the mix," he relates. "It's difficult to explain this medium to some clients. They simply don't understand it. The truth of the matter is, I think even those of us doing the work—and I don't mean us at Segura, Inc., but us as designers—barely understand the whole thing ourselves."

Segura depends on the client to trust the firm's judgment and expertise. "We deal with this issue by asking the client to be prepared to buy something that they may not neccessarily like or understand," says Segura. "We ask them to be big enough to accept our recommendations, even if they don't agree with us." Segura also tries to seek out clients who are receptive to his method of working.

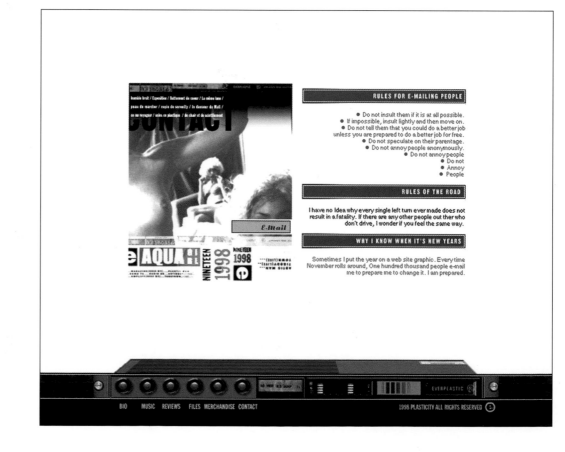

www.everplastic.com

This interactive Web site created for the musical group Everplastic lets fans listen to the rock band's music, view a merchandise catalog, and find out more about their history. The site also lets users enter their name and address on the group's mailing list.
Designer: *Jim Marcus*
Photography: *Jean Hillary, Daniel Givens*

Segura notes that designers are often put in the position of being what he calls the "wrist" of the client. "This comes from the fact that everyone now has a computer that can 'do' what we do, or so they think," he explains. "They pass on a small assignment to the secretary or a friend, or perhaps they do it themselves on their laptop. They can't see that what we do is different—that all designers have a method and have been trained." For Segura, this is where the client trust factor comes in. "There are different types of relationships," he observes. "For example, one can't categorize all marriages as one type of relationship. The same holds true in design. I'm not looking for a one-night stand here. I'm looking for a long-term relationship, and that happens with a combination of communication and trust."

As the demand for work in new media grows, Segura, Inc. has looked into the possibility of establishing a new media division of the company. Since most of the firm's new media work has been from its print clients, the new division will market to prospective clients with new media needs. "New media has a certain degree of positive and negative baggage," says Segura. "Fortunately, there's more positive than negative. So when we say we specialize in new media, that's going to attract a more dedicated client base."

case
study 8

SHARLEEN
SMITH,
USA
NETWORKS

New York City

Early in her career, a love of experimentation and a fearless fascination with technology prompted Sharleen Smith to go from full-time employment as a print designer to full-time student of new media. At the time she was unknowingly priming herself for the transition from graphic designer to interactive producer, the position she now holds as director of new technologies at USA Networks.

Smith was completely enthralled with the computer when she first discovered it in 1990. Because she was moonlighting while working full-time as a designer, Smith appreciated the computer's practical applications. "I could set the type myself, lower my overhead and print out proofs immediately," she relates. "People were amazed at the variety of treatments I could submit within a few days of acquiring copy." Smith soon realized that she was "falling in love with animations and electronic production. I wasn't afraid of technology."

Her increasing involvement with the computer led Smith to leave full-time employment to pursue graduate work in the Interactive Telecom-

> New media has changed my career and career path. Where I was once a graphic designer, I am now a producer.
> —Sharleen Smith

munications Program at Tisch School of the Arts at NYU. "I fell in love with electronic production and wanted more formal training," she states. "In graduate school I discovered the Web, CD-ROMs, interactivity, installation-based interactions . . . all sorts of wonderful things that could be done with media by incorporating the computer."

Smith took five core classes, including programming, critical analysis, video and a new media survey class. During her first semester, she tried to continue her freelance business, but found it too distracting. "It took time away from school and it required a very different mind-set. In school, I was able to discover, or rediscover, a truly creative process of conceiving, design and implementation . . . the freelance print work bogged me down; it got in the way of exploration into electronic media." Smith abandoned her freelance business and lived off her savings plus a stipend she received as a graduate assistant.

Tips

1 Be honest and true to yourself. Are you pursuing new media as a business goal or for personal satisfaction?

2 Evaluate your strengths and desires—what do you love to do? What are you good at? Don't focus on what you *think* you should be doing.

3 Update your skills and tool sets.

4 Don't apply yesterday's aesthetic or communication model to today's media. It is a new medium with intrinsic value in and of itself.

5 Keep in mind that new media is not electronic print, nor is it digital video. It can distribute print and film electronically, but the potential is far greater than just that.

At school she hooked up with Red Burns, the department chair, who became a very strong and nurturing mentor. "Red emphasized content and producing experiences, rather than the technology of new media," says Smith. "It was liberating, especially after being in print and forgetting about the real purpose of communication, which goes beyond winning design awards."

In 1994, Smith was recruited out of graduate school by USA Networks to work on a six-month project. "I started their new media department after being brought in as a consultant," she relates. "After about four or five months, I initiated some of the projects, one of which was a 'Twilight Zone' trivia game that we created for a trade show." Shortly after, her consulting role became full-time employment.

Since then, Smith's department has grown from two employees to encompass fifteen full-time employees and at least as many part-time employees. "It was a match made in heaven," Smith says of her affiliation with USA Networks. "They were open to ideas and I had lots of them. As it turns out, I love being in the television industry. There are great opportunities for synergistic efforts between the new mediums, especially with all the interactive TV initiatives out there now."

"New media has changed my career and career path," says Smith. "Where I was once a graphic designer, I am now a producer." Her role as producer has led Smith to contracting with a larger number of freelancers, consultants and other specialists. "In print, I collaborated with illustrators and photographers," she relates.

"While I continue to work with illustrators and photographers, I am also working with musicians, writers, videographers, engineers, programmers and actors . . .the list is endless."

Working effectively with so many people is a skill Smith picked up in graduate school. "Many projects were group projects due to their scale and complexity," she explains. "I have no aptitude for programming, but a friend was exceptional at programming, so we would often partner."

Working in team situations at school also helped Smith shift her focus from personal fulfillment to the needs of the group. "I learned not to design for myself but for my audience and for the other members of the team," she states. "I had to learn to listen to others as well. I can both lead and follow, but I follow best when I'm working with truly talented people. Today, I recruit talented people and I run my group as a collective."

At USA Networks, Smith finds the projects are as large or small as she and her team can imagine, depending on budget. She has also found that she must wear many hats. "I am manager,

Smith designed this book cover for Henry Holt publishing while freelancing as a cover designer for New York City publishing houses.
Art director: *Raquel Jaramilo*
Designer: *Sharleen Smith*

creative director, executive producer," says Smith. "The variety and diversity I have strived for all along is an integral part of my job description and that makes me very happy."

Smith believes working in new media has enhanced her creativity. "Because collaboration and variety abound in this medium, this gives me the opportunity to explore many ideas and many manifestations

www.scifi.com

The Sci-Fi channel's Web site is an Internet version of the TV/cable channel. It's Web pages are designed to be as dynamic as possible without compromising quality. Since 1995, the site has been upgraded to reflect changing technologies, as evidenced with the evolution of its home page design.

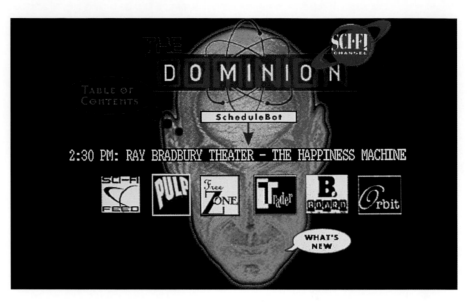

An early home page introduced the use of a Java scroll. Using a framegrab of art previously used on the channel, the face is manipulated and color and text added.

Creative director: *Sharleen Smith*

Designers: *Lisa Orange*

In order to swap out more information for more timely promotions, this home page was designed with smaller elements. Because the channel had just embraced its international feeds with a launch in Europe and a block of programming in Latin America, the graphic is an animated GIF tower radiating the signal.

Creative director: *Sharleen Smith*

Designer: *Troy Sostillo*

This page is a migration towards a much more modular front page with on-air content more segmented from online content. There was a need for a "bulletin board" to promote special events, which is the center image. Also, a more text-centric home page made sense because it would allow for a faster load time.

Creative director: *Sharleen Smith*
Designer: *Carlos Carranza*

of ideas," she says. "I've had to develop Web sites, installations, exhibits, interactive games and, most recently, an interactive television show. Within each distribution model, there are so many genres such as narratives, games, fact, fiction and so on."

Not surprisingly, Smith has found that designing for print does not hold the same interest for her as it once did. "I still consider myself a designer in many ways, but I feel that print, in general, is now restrictive," she states. "As much as I love type, color and composition, I am also learning to work with movement and sound."

Smith says she feels like a pioneer at a point in time when new territory is being explored in the field of communication design. "I feel fortunate to be a creative person working in this unique time in our society's evolution," she explains. "To be part of an entirely new form of media and communication is not a common thing. I feel very excited."

case

study 9

ZENDER +

ASSOCIATES

Cincinnati

Although it was just five years ago that Zender + Associates began working in Web site and interactive CD-ROM development, the move capped a twenty-year interest in moving type, animated images and computers for principal Mike Zender, who was first introduced to computerized typography as a graduate student at Yale. "I immediately realized digital media handled communication better than tangible physical media. It was much more flexible," he explains.

In 1977, shortly after graduating from Yale, Zender founded Zender + Associates, purchasing the firm's first computer in 1983. "We bought one of the first IBM PCs with a 2MB Corvus external hard drive and a modem to transfer copy to the typesetter," he relates. Zender had software written to compile time sheets and track jobs.

The firm continued to stay on top of the increasing computerization of print, constantly upgrading and purchasing new equipment as it became available. However, in 1993, Zender found himself facing some concerns about his

> We have always worked in teams, but new media demands further specialization and teamwork.
> —Mike Zender

firm's future. "We were moving into interactive CD-ROM development, and we needed to know what that was going to mean to the company," he recalls. To determine how the firm's current capabilities measured up to their future involvement in new media, he hired an experienced advertising producer with a master's degree in instructional systems technology to research and develop the firm's interactive capabilities.

Meanwhile, the Internet was beginning to attract attention and Zender was staying abreast of its development. In the fall of 1994, as president of the Cincinnati chapter of the American Institute of Graphic Arts (AIGA), Zender got an exciting idea for the first and only AIGA "virtual event" to introduce designers to the new World Wide Web. "The event was held in the Cincinnati Bell offices in downtown Cincinnati—the only place with an Internet connection and a large screen," he recalls. According to Zender, one hundred

(Above) National Geographic Society Interactive Map

This interactive map appeared on the National Geographic Society's Web site. Users could click on a national park and receive additional information on the park's location, attractions and facilities.

Designer: *Mike Zender*

(Right) www.zaring.com

The Zaring Web site was designed to be the main artery for the Cincinnati-based home builder's information distribution. Both the "In the News" and "Zaring on Wall Street" sections update themselves every five minutes, ensuring any company-issued press releases appear online as soon as they are public knowledge. Through a variety of links and pop-up menus, the viewer can easily move through the site to get information about the community, view floor plans, and obtain directions to home models and office locations. The navigational trail at the top of the page grows as the viewer moves to different levels.

Designer: *David Tong*

Writer: *Patty Payne*

Production: *Jason Huck, Mike Hahn*

welcome to ZARING HOMES, INC.

Join us in our quest to become The Preeminent Builder in the U.S.

COMPANY & HISTORY

CITIES & COMMUNITIES

HOME MODELS

IN THE NEWS

ZARING ON WALL ST.

CAREER OPPORTUNITIES

BLUE CHIP MORTGAGE

TALK TO ZARING

Website Design and Development by Zender+Associates.

Copyright 1998, Zaring Homes, Inc. Terms of Use

Cities & Communities | Cincinnati

CINCINNATI

BUILD A ZARING HOME
ON YOUR OWN LOT

COMMUNITIES:

Babson Park

Huntington

Lakota Springs

Legendary Run

The Oaks at
Crooked Tree

The Orchard

Parkside

Paxton Lake

Polo Fields

The Reserve at
The Oasis

River Oaks

Summerfield

Sutherland

White Blossom

Whitmore Woods

Photo© 1997 D. Steinbrunner

Headquarters to Zaring Homes, Cincinnati, Ohio has been acclaimed "the most livable city in North America" by *Places Rated Almanac*. The Reds, the Bengals, and the Cyclones are Cincinnati hometown favorites. Scenic parks, the Cincinnati Zoo, and riverboat cruises are ways to relax, Cincinnati-style.

The combination of an international transportation hub, a rich variety of cultural and arts institutions, and a powerful gathering of corporate headquarters (GE Aircraft Engines, The Procter & Gamble Company) makes Cincinnati a challenging city with high expectations. Zaring has met the challenge by designing innovative homes and by pleasing buyers throughout the home buying process.

Contact a Zaring Representative in Cincinnati for more information.

Copyright 1998, Zaring Homes, Inc. Terms of Use

Cities &
Communities

CITIES & COMMUNITIES

CHARLOTTE

CINCINNATI

DAYTON

INDIANAPOLIS

LOUISVILLE

NASHVILLE

RALEIGH

Beautiful gateways and landmark entrances showcase Zaring communities. Desirable locations offering prestige, value, security, and easy accessibility characterize our neighborhoods.

Headquartered in Cincinnati, Ohio, Zaring Homes has divisional offices in Louisville, Kentucky; Indianapolis, Indiana; Nashville, Tennessee; and Raleigh and Charlotte, North Carolina. In each market, we provide homes with extensive options and regional character, never wavering from our commitment to complete customer satisfaction.

As we continue to grow, the same desirable characteristics that have made Zaring a success in Cincinnati are the same in our new locations: economic stability, steady growth pattern, and architectural styling compatible with our image.

Copyright 1998, Zaring Homes, Inc. Terms of Use

Home Models | Ashville | Floorplans

ASHVILLE

1ST FLOOR

2ND FLOOR

OPTIONS

FIRST FLOOR SECOND FLOOR

Copyright 1998, Zaring Homes, Inc.
Terms of Use

OPTIONS

Home Models | Ashville

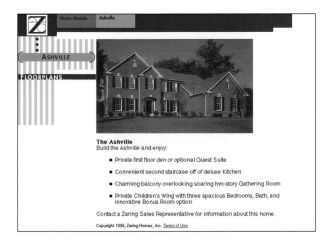

ASHVILLE

FLOORPLANS

The Ashville
Build the Ashville and enjoy:

- Private first floor den or optional Guest Suite
- Convenient second staircase off of deluxe Kitchen
- Charming balcony overlooking soaring two-story Gathering Room
- Private Children's Wing with three spacious Bedrooms, Bath, and innovative Bonus Room option

Contact a Zaring Sales Representative for information about this home.

Copyright 1998, Zaring Homes, Inc. Terms of Use

Steed Hammond Paul Interactive Presentation

This interactive presentation, developed for Steed Hammond Paul Architects, was created in Macromedia FLASH. The presentation shows the firm's process and was designed to stimulate creative thinking with its analogy of the "golden mean." Its flexible format allows it to be used in several ways. A player version exists on CD-ROM and on diskette. It also exists as a password-protected area of the Steed Hammond Paul Web site.

Art director: *David Tong*
Designers: *David Tong, John Paul Armstrong*
Writers: *Zender + Associates, Steed Hammond Paul*
Production: *John Paul Armstrong*

designers "oohed and aahed" as they visited the Web for the first time.

Working on this project had the advantage of introducing Zender + Associates' capabilities to Cincinnati Bell, which led to a more lasting relationship when Cincinnati Bell hired the firm to develop and design FUSE, Cincinnati Bell's Internet service and Web site. As interest in the Internet increased, research and development efforts at Zender + Associates were redirected toward the Internet and its potential.

At about the same time, Zender and partners Jeff Fine and Rick Alberson were co-authoring a book called *The Designer's Guide to the Internet,* conceived as an introductory overview of the Internet for design professionals. "The book project was great for us because it forced us to

dig deeper into the Internet and look beyond technology to think conceptually about the meaning and the impact of the medium," says Zender. "We hired our first programmer while writing the book, to help us with the research and to help 'program' our first Web sites."

As they continued their research, Zender and his partners began to recognize the business opportunities of the new medium. "From the beginning it was clear that the new medium has a bias toward changing information, requiring continual revision and updating of content," he explains. "This continual updating was a key strategic reason we moved into Web development. Design firms often have short bursts of activity, doing an identity program or corporate brochure, with long periods of inactivity. This is

hard on cash flow. Web revisions are a means to flatten that."

Zender and his partners also realized they would need a major restructuring of computers and staff in order to accommodate the new work. With the development of their first site came the purchase of a Sun server to host the sites they developed, as well as the hiring of additional programming staff and other Web design specialists.

Today, Zender + Associates has a variety of servers which host most of the sites they design. "The move to computer-based publishing media immediately raised the need for computer programming well beyond HTML tags," says Zender. "We recognized that many sites would be more than online brochures and would, in fact, be computer applications."

Partner Jeff Fine championed the development of databased applications. The staff is now divided along the lines of design development and programming/software development. "The evolving nature of the technology requires constant learning," says Zender. "We did not get

formal training, but invested time and energy in research and development by hiring programming staff."

As Zender and his group got more involved in new media, other opportunities emerged. "The Internet, because it involves continuous revisions, has re-oriented us toward service and cultivating relationships," says Zender, "It has helped us into the consulting role we have always sought. Since the client knows so little about new media projects, and the projects frequently span several internal client departments, we are often called upon to consult with clients on organizational communications issues across the board. We often help our clients interview and hire their new media managers/producers as well as develop organization communication strategies."

Zender sees his firm's involvement in the total picture as the key to its future and the future of the profession, "moving from working almost excessively on designing specific projects to designing communication strategies for clients, including many individual projects," says Zender.

"This type of design work has higher value, commands higher fees, and generates better and more measurable results. It is our best protection against the vast sea of freelancers and one-person shops."

The move into new media has impacted Zender + Associates' staff in different ways. "Many of our older designers are cool to new media, preferring to play a design director/consultant role," says Zender. "They have absorbed so many technological changes that, although we have required they learn HTML and other basic aspects of Web development, we have permitted some to opt out of working in new media." Zender says this hasn't been a problem. "Our print work is increasing," he notes. "Business activity has a self-sustained quality. We now get work from clients who want an integrated brochure and Web site. The digital medium offers things print can't, such as interactivity, retirement calculators, database searches, and product ordering. On the other hand, print has things the new media can't deliver such as hi-res images, a tactile quality and fine typography."

When asked how he feels about new media, Zender expresses mixed feelings. "I hate it because much of it is terrible from a design standpoint," he says. Zender cites low-res images, a limited color palette and poor typography as examples of the medium's limitations. "Most of the Web is worse than the worst junk mail," he states.

"No one, myself included, really understands new media—what its proper visual and syntactic vocabulary is, its voice and how it should be cultivated," says Zender. "Because it is still evolving, changing almost daily, it will take some time to master it." Yet there is something that still draws Zender to the medium. "It is dynamic and interactive. It opens up two-way communication on a level never seen before," he explains. "It involves sound and motion, an enhancing combination. It has tremendous potential."

case
study 10

PINKHAUS/

THE

DESIGNORY

Miami & Long Beach

Pinkaus has gained an international reputation for its brand-building and design strategies for a distinguished client list that includes NIKE, Motorola, Sterling Commerce and the Lipton Tennis Tournament. You would think that founder Joel Fuller would have been satisfied with the healthy growth of his Miami-based firm. But in 1995, Fuller decided he wanted more. "I realized the world was changing, and I wanted to be able to compete at a higher level," he relates when recalling his decision to merge with the Designory, a design firm based in Long Beach, California.

One of the largest design firms in the country, the Designory is well known for producing varied marketing efforts for auto industry clients such as Mitsubishi, Nissan and Porsche. Fuller got well acquainted with the firm and its principals while Pinkhaus was working on an interactive kiosk for Motorola. The two firms shared information on the interactive projects on which they were working. "They were involved in the Mercedes CD-ROM at the time and were getting involved in interactive technology with their clients," says Fuller.

> Four years ago, clients were going to the interactive companies to do new media work. Now we find almost 100 percent of these clients are coming back to us saying, "You guys know the touch, smell and feel of our brand. We'd rather have you patrol that and deal with the interactive guys."
> —Joel Fuller

Fuller was impressed with the Designory's groundbreaking work on the Mercedes CD-ROM as well as the company's Interactive Media Group. The Designory was attracted to Pinkhaus's client list and its creative portfolio. The merger provided both companies with bicoastal strength and Fuller with the instant digital expertise he needed to catapult Pinkhaus into designing new media projects.

Since the merger, Pinkhaus and the Designory have gotten even further involved in new media, creating Web sites and other interactive projects for a diverse range of clients. In addition to providing Pinkhaus with basic knowledge of new media technology and design, the Designory has steered Pinkhaus in the direction of many technical providers who have collaborated with both the Designory and Pinkhaus in the production of their new media projects.

Mercedes Interactive Sales Presentation

This award-winning CD-ROM set a precedent for the automotive industry. Created to launch the new E-Class Mercedes, it was distributed in advance of the introduction date and programmed to release only a specific portion of its content on each of the five days prior to the E-Class introduction. By the fourth day, the consumer knew everything about the E-Class except what it looked like. On the fifth day, consumers were treated to a five-minute, full-motion video.

Design: *The Designory*
Interactive Firm: *COW*

Motorola Paging Products Interactive Kiosk

(On this page and next) This interactive presentation was created by COW and Pinkhaus for the Geneva Telecom Show. After brainstorming with COW, the designers at Pinkhaus worked out a rough visual storyboard. Pinkhaus wrote and directed the presentation; COW designed and produced it using their in-house film, music, editing and mixing capabilities. COW also designed the kiosks, specifying the equipment and directing installation.

Design: *Pinkhaus Design*
Interactive Firm: *COW*

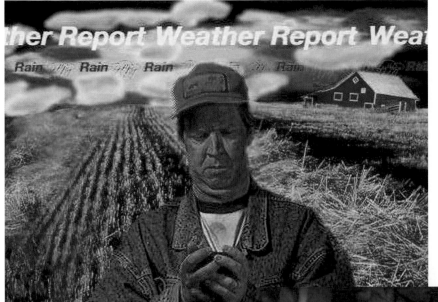

Tips

❶

Keep it simple. The main purpose of most Web sites and kiosks is to give quick, easy access to information.

❷

Don't get mesmerized by technology. Don't use tricky techniques simply because you can. They often slow things down.

❸

Watch your own behavior on the Web and let that be your guide to how you should design.

❹

Consider download time when designing a Web site. Don't forget that users get impatient if graphics and the information they're trying to access take forever to get to.

For Fuller, partnering with a variety of firms that provide technical expertise makes good business sense. "Our business isn't based on interactive, it's based on brand-building," he says. "We decided that the industry is changing so much and so radically it would be smart for us to partner with people who we think are most appropriate for each job." Fuller observes that this attitude is typical of other collaborative situations in which designers get involved. "When you work in television, you find the appropriate director to direct your commercial," says Fuller. "It's the same when choosing a photographer. We go out and find the appropri-

ate people based on the project and its objectives. Once the right people are in place, it becomes a total team effort."

Frank Cunningham, senior writer for Pinkhaus and collaborator with Fuller on many of Pinkhaus's interactive projects, says that there are many benefits to outsourcing this type of work. "You have the ability to choose from a variety of specialists for various jobs," he says. "You avoid the staffing problems you might have if you decide to beef up staff to include codewriters and developers."

Pinkhaus selected Santa Monica-based COW to provide the interactive programming and production skills on the Motorola kiosk, a project for which Pinkhaus provided creative direction. After providing the initial framework for the interactive presentation, including concepts and copy, the Pinkhaus team brainstormed alone and with COW to develop the visual concepts. Upon client approval, COW produced the work with creative guidance and supervision from Pinkhaus.

www.sterlingcommerce.com

Hired by Sterling Commerce to redesign its existing Web site, Pinkhaus brought a new look and a logical presentation of merged content to the revamped site. Deployed in 1998, the new site gave the global enterprise and its product families a unified appearance. Pinkhaus partnered with Genex, which was hired to produce the site. Together they established a successful framework for navigating the world of electronic commerce. While the site was being produced, the amount of content continued to grow. At last count, this site was over 1200 pages long and growing.

Design: *Pinkhaus Design*

Interactive firm: *Genex*

When Pinkhaus develops a Web site, most of the content is gathered beforehand during meetings with the client and designers and developers. From there, Cunningham and his design team draw up a schematic of various pathways of information that will go on the site. The design is then worked out in QuarkXPress. "We can send a disk to the client with Quark files of the design, and we go over the design with them on the telephone. After the design is approved, the developers begin final code development."

Cunningham sees new media as an opportunity for designers to explore a new creative venue. "You have more opportunities to lead the audience down interesting sidetracks and entertain them with applets or give them information in the form of Java scrolls and so forth," he says. However, Cunningham observes that new media can also stifle creative expression. "Writing for the Web, for the most part, is a stripped-down, bullet-point prose," he states. "People go to most sites for information and it's our job to make that information easy to get and digest."

According to Cunningham, download time currently has a big impact on the role of design, especially when designing for the Web. "Graphics, particularly in a business site, tend to be inessential, so many people set their browsers to eliminate the graphics and just display the information they are after," he explains. "Although people still respond more positively to something attractive, the overall placement of information and navigation through the site are vastly more important than graphic design."

Cunningham sees Web site design as a means for designers to control content. "The Web is wonderful in that way because you can put up as much copy as you want—it just needs to be organized in such a way that viewers who want to get in, get their information and get out quickly can do so, and those who want to dig for the information can do that," he explains. "Our clients shouldn't have to pick and choose. It's our job to put the 'it' in the proper place. The great thing about interactive work, is it allows one to communicate in a dynamic way . . . it becomes a story. You can do everything."

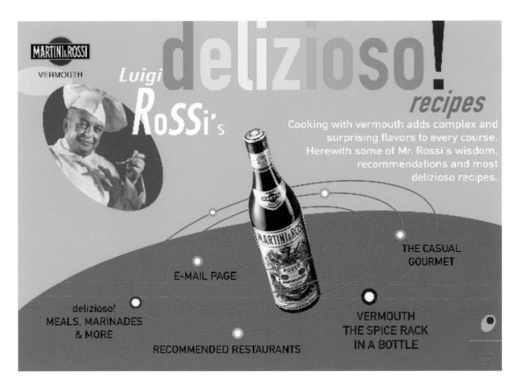

www.bacardi.com
The mission of this series of pages—part of the Bacardi Web site—was to reposition vermouth as a versatile and sophisticated (yet simple) cooking ingredient. The client bought a participation in the Epicurious Web site and Pinkhaus developed a special Martini & Rossi section to introduce the various uses of vermouth. It provided recipes for cocktails and main courses, as well as a list of recommended restaurants and bars, and a new image of vermouth emerged.
Design: *Pinkhaus*
Copywriter: *Pinkhaus*
Interactive Firm: *Pod*

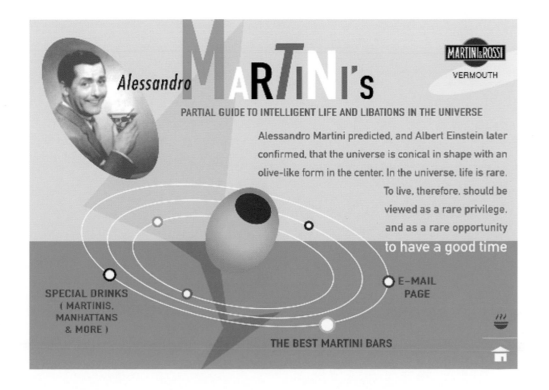

case study 11

INTERACTIVE BUREAU

New York City

Roger Black

Interactive Bureau began in 1994 as the brainchild of Roger Black, Jock Spivy and David Berlow. The firm, which provides online creative and consulting services and technical implementation to a distinguished, international client roster, was formed when renowned publication designer Black joined with former colleagues Jock Spivy and type designer David Berlow. Having recognized the potential of the Internet early on, this trio understood that design was essential to the development of the Web.

Though he is now recognized as a new media innovator, Roger Black has never abandoned his interest in print. Black began his career in 1971, as editor and designer of *Amerika*, a one-shot college newspaper supplement, when he was still at the University of Chicago. His work as associate art director and art director for *Rolling Stone* magazine in the mid-1970s earned him recognition as an influential designer in the magazine and newspaper industries. As a pioneer of desktop publishing who has introduced desktop efficiencies and digitized design to dozens of magazines and newspapers, Black was a natural candidate for the Internet.

> With the Internet, there are no longer content providers and readers. The new order makes the viewer into the producer, the director, the editor. It's a collaboration. A designer can put a button on a page, but he can't tell 'em where to click.
> —Roger Black

Former vice president of Welch Publishing Group, co-founder Jock Spivy is a veteran publisher who began his career in the circulation departments of *Time* and *Rolling Stone* magazines. By the early 1990s, Spivy was already involved in CD-ROM projects, including an early project, *The Craftsman* on CD-ROM, a massive digital archive and electronic replica of all 183 issues of Gustav Stickley's turn-of-the-century *Craftsman* magazine. He also understood that a new media business required sophisticated planning, strong management and team-building to succeed.

The Craftsman on CD-ROM.

This CD-ROM broke new ground in digitized publishing by replicating all 183 issues and 28,000 pages of Gustav Stickley's Craftsman magazine. This completely searchable, eight-disk archive documents the American Arts and Crafts movement. The archive utilizes Adobe's PDF format to electronically duplicate every page, ad and illustration in the original periodicals. Adobe Acrobat provides the search capability for this project.

With Black (the chairman of the company) directing the creative output, and Spivy (the managing partner) overseeing the business aspects of the firm, Interactive Bureau has grown rapidly. What began as a staff of five working in a walk-up office in a townhouse has become an operation with more than thirty-five people with offices in New York and San Francisco and partner offices in England, Mexico, France and Spain.

Today, the firm provides online creative services, business strategies and engineering to an international client roster including Barnes & Noble, @Home, Columbia University, the Discovery

Channel Online, Hitachi Data Systems and MSNBC. The company credits the publishing and print backgrounds of its founders for its success and believes this has helped it become a leader not only in Web design, but also in strategic planning for businesses online.

According to Interactive Bureau editor Alexandra Anderson-Spivy, constant communication with the client is a must when starting to plan

www.barnesandnoble.com

Designing and helping to build the Barnes & Noble online bookstore took Interactive Bureau over a year. Bold typography and distinctive templates help users quickly and easily find the information they need. Interactive Bureau also suggested many user-friendly interactive features, such as online chat rooms.

Creative director: *Robert Raines*

❶

Put content on every page. Designs shouldn't be mere decoration.

❷

Don't design pages that require scrolling.

❸

Make the content easy to read and easy to navigate. Make firm editorial decisions about hierarchies of information.

❹

Don't confuse the end user.

❺

Don't use tiny type.

❻

Customize content for the Web.

❼

Find out what the client wants before you start designing.

www.discovery.com

The Discovery Channel was one of Interactive Bureau's first clients (1994–1995). The award-winning site incorporates bold fonts, clear information hierarchies, lively pictures and logical, easy-to-use navigation systems. The site's lead designer, Jessica Helfand, helped to supervise a large team that continually maintained the site's extensive editorial and illustrative content.

Designers: *Roger Black, John Schmitz, Jessica Helfand*

and design a Web site. "We go through an exhaustive consultation process where we work closely with the client to identify what needs to be on the site and how it will function. We have found that applying a very logical process to the development of each client's site is crucial to success." Called "The Method" at Interactive Bureau, this is a four-step process by which a Web site is designed and built.

The first step in this process is the preparation of a brief for each client's job. Outlining design, content and technical requirements, the brief comprehensively describes the parameters of the job and what the decision-making process will be. "As early as possible, the Interactive Bureau team establishes a primary client contact, identifies and involves all relevant constituencies, develops a site map, and gets underway any necessary engineering and technical implementation," explains Anderson-Spivey.

After the client approves the brief, Interactive Bureau creates a set of trial pages that represent several stylistic approaches to the project. These pages have simple programming so that the client can get a true sense of functionality. Creative direction is also established at this stage. In the prototype stage, more templates and key pages are created and advanced programming is implemented. Intensive testing and debugging is built in at this stage and continues into the next. Upon client approval of the prototype, the site is launched. Interactive Bureau often works with clients to hire and organize in-house staff and provide training, backup and ongoing creative support after a site is underway.

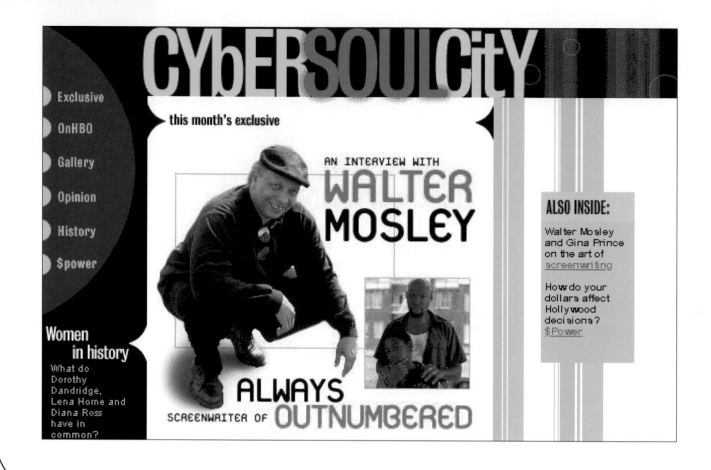

www.hbo.com

HBO CyberSoulCity

HBO wanted CyberSoulCity, a new for-the-Web-only feature, to promote programming—as well as the discussion of personalities, issues and entertainment—to a hip, urban, ethnic audience. Interactive Bureau's design team met the challenge and designed a site that appeals to a specific contemporary audience. (The site links from the HBO site.)

Creative director: *Theo Fels*

Working on the Web site development requires an intensive kind of teamwork. Because of this, the firm utilizes Black's ability to build and inspire creative collaborations among creative people. According to Black, collaboration doesn't just happen in house. He emphasizes that "with the Internet, there are no longer content providers and readers. The new order makes the viewer into the producer, the director, the editor," says Black. "It's a collaboration. A designer can put a button on a page, but he can't tell 'em where to click."

Black expects new media to expand even further. "New media makes everyone—clients, readers, customers—into publishers," he says. "We also see the expansion of the Internet and its development as a primary vehicle for transactions, interactions and information retrieval making it very different from the less fluid delivery system of the world of print."

www.rogers.com

In 1998, Interactive Bureau helped create a powerful Web presence for Rogers Communications, Canada's media giant, by providing them with a cohesive redesign and a new online strategy. Interactive Bureau's design team gave Rogers a fully integrated "face," bringing together a variety of divisional sites under one banner: "Information, Communication and Entertainment." All divisions now have a consistent look and feel and an integrated navigational system.

Designers: *Theo Fels, James Caldwell*

case study 12

RONNIE
PETERS,
TIME
WARNER

New York City

" I first became aware of new media at the Rhode Island School of Design in 1988," says Ronnie Peters, recalling his college years. "At the time, I also worked part-time as a designer at a research center at Brown University," he relates. "We were developing the first Hypertext system, called Intermedia. Used by teachers, this system was created to enable them to teach an entire class using a computer network, without ever meeting the students face-to-face."

Peters says this early exposure to the potential of interactivity captured his imagination. "It seemed very interesting to me," he states. "It was the first computerized, nonlinear, seamless information environment I had ever seen. I ended up doing my master's thesis on Inter-media and realized the differences between designing, reading and experiencing information from computer screens vs. more traditional mediums such as print and three-dimensional graphics."

After receiving his graduate degree from RISD, Peters started a computer design company with two partners. "Most of our projects pertained to information graphics and designing for computer screens," he recalls. "By 1994 I was de-

Because the Web is still about static text and images on the screen, there is still this analogy with print and a false impression that the Web might replace print. The comparison will disappear as we gain more understanding of the Web, as the bandwidth increases and we start to use the Web for what it is really good for.
—Ronnie Peters

signing exclusively for computer screens, and I have rarely done any print design since. It was clear to me from early on that this 'new media' wasn't going to go away, especially when the Web came along."

Peters is now totally engrossed in new media as design director for Time Warner. "I only do design work related to the delivery of our content in some form of new media," he states. "The whole existence of the organization is due to the Web, and our entire staff exists because of the Web." Peters and his group design sites associated with magazines such as *Time*, *Money*, *People Weekly*, *Life* and *Fortune*, as well as Web sites for Dr. Ruth and Dr. Weil.

When asked to describe what makes new media unique to other media, Peters notes that the biggest difference between designing for

Courtesy of Ronnie Peters and International Business Machines Corporation. This is a drawing and not an exact replica.

Realistic ThinkPad

This computer drawing was created by Peters in an early version of FreeHand while attending graduate school at RISD. The illustration was part of an assignment to design the setup manuals for IBM's first ThinkPad computers. Peters was fascinated with the amount of detail he could put into a computer rendering. "The drawing was made at exactly 100 percent scale," says Peters. "I set the computer's measurement preferences for millimeters and drew every part of the computer in exact detail."

Illustrator: *Ronnie Peters*

new media and print is the site architecture and navigation. "Books, magazines and other printed media have well-established conventions and methods for the structure and placement of information," he explains. "There are covers, a table of contents, page numbers ... a whole set of criteria long associated with the production of printed materials." Peters points out that we're so familiar with these conventions we take them for granted. New media, on the other hand, challenges designers to deal with a different level of perception. "When working on a Web site, I have to think about a whole new set of factors," he explains. The structure of content in a seamless environment imposes an interesting set of issues for the Web designer, such as how the user moves around the system."

Peters is often involved in translating magazines and other printed materials into a Web site

design. He's found that what reads well in print doesn't necessarily work on the computer screen. "We started by reappropriating a lot of each magazine's content onto the Web," he explains. "We discovered it strains the eyes and it's harder to read larger amounts of text on screen. And, it's probably not a good business model to simply repeat the entire magazine on the Web for no fee. Why buy a magazine that you can get online for nothing?"

His solution was to support each magazine with a Web site and have the site support the magazine. This was not a new concept for Peters. "We did that at WGBH with television programming," he relates. "The TV documentary program *Frontline* did an investigation into the Waco, Texas incident. There were a lot of audiotapes of David Koresch and the FBI. Though interesting and pertinent, there was simply too much of it for the TV show. We converted the tapes to Real Audio and put them on the Web site, added bulletin boards, images and some editorial and we had a winner." During the TV show, the Web site was promoted as a means of getting more in-depth information. "This model worked really well," says Peters.

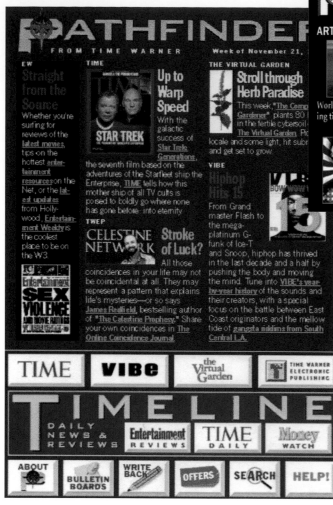

Pathfinder.com is Time Warner's Web site. A work in progress over several years, the development of the Pathfinder Web site reflects the refinements and improvements that have been made as the result of evolving new media technologies and a growing knowledge of the medium.

(Left and above) *Early Pathfinder home pages were heavy with graphics and lacked a sense of hierarchy. They also failed to tell the viewer how to access the vast network that lies below the home page. While reversed type can look dramatic, it is harder to read than dark type on a light field. The branding of all the Web sites that make up the Time, Inc. network is not visible enough on these pages.*

Art director: *Ronnie Peters*
Designers: *Paul Schrynemakers, Chip Toll, Melanie McLaughlin, Paul Notzold, Kwan Kim, Christina Tzauras*

Peters says his ideas for Web sites are limited to some degree by the narrow bandwidth by which the average user connects. "I see elaborate designs that are graphically heavy, using Java, frames, etc.," says Peters. "But unless there is something really compelling about what is on these pages, the average user will not have the patience to wait for the page to download." Peters and his staff develop Web pages that will download quickly on a 28.8 modem.

Peters works with teams that usually consist of designers working with editors. When designs are finalized, they're given to production staff who are responsible for translating the designs to finished HTML, and a technical staff for back-end programming. "It wouldn't be possible or good business to expect designers to produce the entire project on their own," says Peters.

The involvement of so many individuals in Web site development means that designers need to be team players. "Cooperation and collaboration are very important," says Peters. "It is nec-

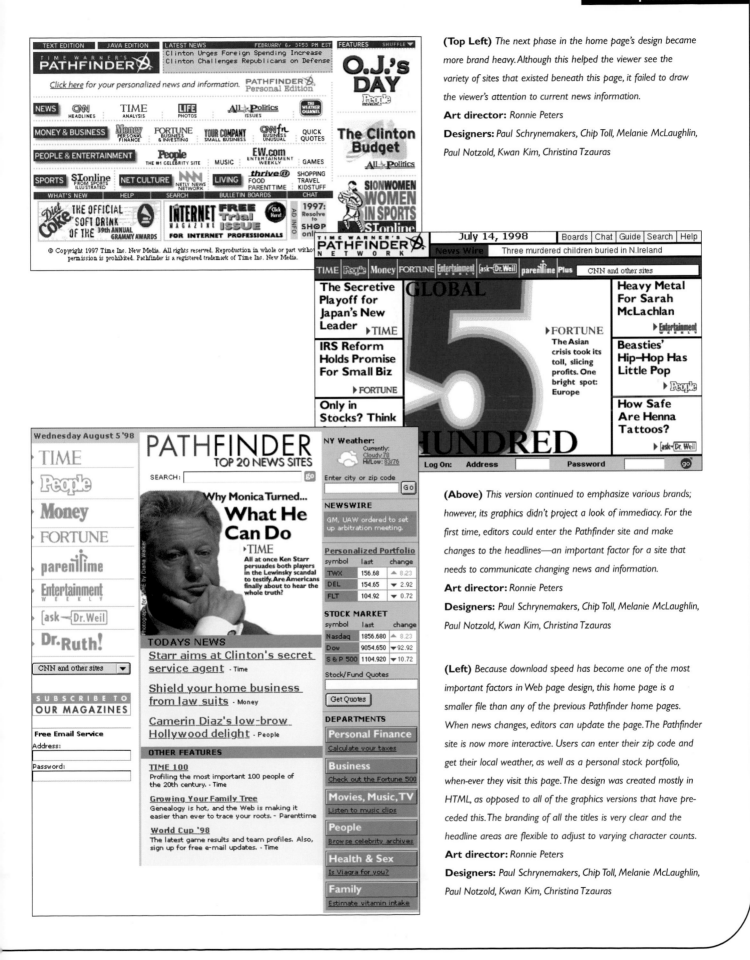

(Top Left) *The next phase in the home page's design became more brand heavy. Although this helped the viewer see the variety of sites that existed beneath this page, it failed to draw the viewer's attention to current news information.*

Art director: *Ronnie Peters*

Designers: *Paul Schrynemakers, Chip Toll, Melanie McLaughlin, Paul Notzold, Kwan Kim, Christina Tzauras*

(Above) *This version continued to emphasize various brands; however, its graphics didn't project a look of immediacy. For the first time, editors could enter the Pathfinder site and make changes to the headlines—an important factor for a site that needs to communicate changing news and information.*

Art director: *Ronnie Peters*

Designers: *Paul Schrynemakers, Chip Toll, Melanie McLaughlin, Paul Notzold, Kwan Kim, Christina Tzauras*

(Left) *Because download speed has become one of the most important factors in Web page design, this home page is a smaller file than any of the previous Pathfinder home pages. When news changes, editors can update the page. The Pathfinder site is now more interactive. Users can enter their zip code and get their local weather, as well as a personal stock portfolio, when-ever they visit this page. The design was created mostly in HTML, as opposed to all of the graphics versions that have pre-ceded this. The branding of all the titles is very clear and the headline areas are flexible to adjust to varying character counts.*

Art director: *Ronnie Peters*

Designers: *Paul Schrynemakers, Chip Toll, Melanie McLaughlin, Paul Notzold, Kwan Kim, Christina Tzauras*

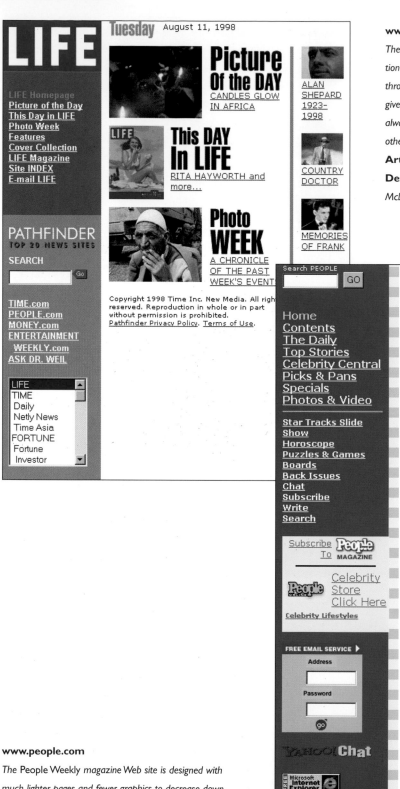

www.life.com

The Life *magazine* Web site employs left-side navigation that is visible on the home page and every page throughout the site. This type of navigation system gives users a good orientation mechanism—they always know where they are in the site and what the other pages and areas are.

Art director: *Ronnie Peters*

Designers: *Paul Schrynemakers, Chip Toll, Melanie McLaughlin, Paul Notzold, Kwan Kim, Christina Tzauras*

www.people.com

The People Weekly *magazine* Web site is designed with much lighter pages and fewer graphics to decrease download time. Peters and his staff used HTML coding, colored fonts and table cells to give the pages a lively look while minimizing the size of the pages and their download time.

Art director: *Ronnie Peters*

Designers: *Paul Schrynemakers, Chip Toll, Melanie McLaughlin, Paul Notzold, Kwan Kim, Christina Tzauras*

essary for our designers to realize that there are conventions and rules that are being implemented across an entire network of sites. While design plays an important role, it is just one of many components."

Peters sees a growing role for the Web at Time Warner, but will the Web eventually replace print? "Because the Web is still about static text and images on the screen, there is still this analogy with print and a false impression that the Web might replace print," he observes. "The comparison will disappear as we gain more understanding of the Web, as the bandwidth increases and we start to use the Web for what it is really good for." Peters thinks the Web will replace some of the things currently being done in print, but not entirely. "But one will not replace the other," he states. "They are just different ways of delivering information. At Time, Inc. we've gone so far as to say if it can't be done in the magazine, it can't be done on the Web and vice versa."

www.fortune.com

The Internet is a good medium for up-to-the-minute financial information. The Fortune magazine site delivers uncluttered, clearly layed-out financial news, quotes and data for the investor. Left-side navigation throughout the site gives viewers a consistent means of navigation.

Art director: *Ronnie Peters*

Designers: *Paul Schrynemakers, Chip Toll, Melanie McLaughlin, Paul Notzold, Kwan Kim, Christina Tzauras*

case study 13

HALL KELLEY

Marine on St. Croix

Michael Hall and Debra Kelley

H all Kelley started in identity development largely for print, but the firm's expansion into new media strikes Hall, founder and partner of Hall Kelley, as a natural progression. "I grew up in the age of the space program and the Jetsons, so the notion that we would one day communicate by pushing buttons and looking at computer screens was a given," explains Hall. "The actual development of new media has always seemed painfully slow to me—I had imagined that computer technology would just appear one day in its final form. Of course, the process is composed of lots of little steps, many of which are not forward."

Hall began his design career seventeen years ago as a freelance designer. Trained as a scientist, Hall worked in various commercial and academic laboratories before deciding to pursue a career in what was then referred to as "commercial art." He attended two semesters of technical school before striking out on his own. After a few successful years of freelancing, Hall joined forces with client Debra Kelley. "Her communication skills and my design work complemented each other well," says Hall. "Over the first few

Our firm is focused on visual identity and our feeling is that new media will continue to be in demand for some time. In fact, with the advent of new media, a company's identity can become more muddled than ever. Because of this, strong identities that are engaging and can relate a Web presence to print and other media are more important than ever.
—Michael Hall

years, we grew our firm, Hall Kelley, to ten employees, got married, had children, weathered the turbulent business climate of the late 1980s, downsized to four employees, and focused on visual identity design. We operated in downtown Minneapolis for many years before getting the itch to move to the country in 1994, when we moved our firm to a barn and our family to a house a few yards away. The barn/office has worked better than we imagined, owing in part to electronic transfer of information."

The firm approaches new media projects in

(Below and right) www.ellerbecket.com

Ellerbe Becket, one of the largest architectural, engineering and construction firms in the United States, promotes its capabilities through its print materials and its Web site, all designed by Hall Kelley. Within the Gallery section, users choose from five major market segments to view projects the firm has designed. Hall Kelley also designed twenty icons representing Ellerbe Becket "Centers of Knowledge." The icons appear on the Web site and are used on Ellerbe Becket's printed materials.

Designer: *Michael Hall*

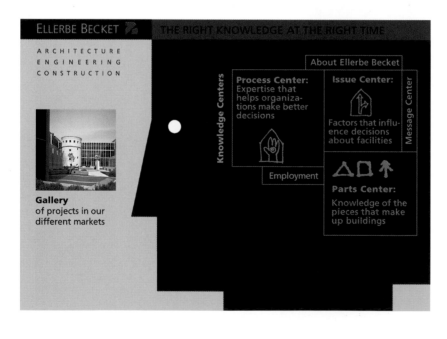

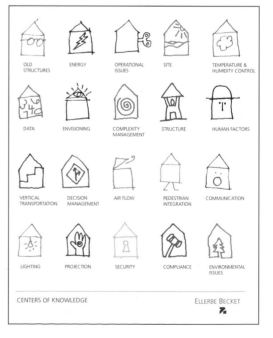

ELLERBE BECKET GALLERY
HOME | MAIL | CORPORATE | EDUCATION | GOVERNMENT | HEALTH CARE | SPORTS

ELLERBE BECKET GALLERY
HOME | MAIL | CORPORATE | EDUCATION | GOVERNMENT | HEALTH CARE | SPORTS

Introduction

Indiana University

Iowa State University

University of Notre Dame

University of Notre Dame College of Business,
Notre Dame, Indiana
One of the latest facilities in our 46 years with Notre Dame,
the building reinterprets the collegiate Gothic style on campus.
Successful school designs today must integrate the needs of
donors, faculty, students, technology and a host of other
requirements.

ELLERBE BECKET EMPLOYMENT OPPORTUNITIES
HOME | MAIL | JOB LISTINGS | JOBS BY LOCATION | APPLICATIOIN

ELLERBE BECKET GALLERY
HOME | MAIL | CORPORATE | EDUCATION | GOVERNMENT | HEALTH CARE | SPORTS

Introduction

Indiana University

Iowa State University

University of Notre Dame

University campuses are cultural treasures, a
community's prize possession. Buildings and
grounds embody an institution's spirit, traditions
and mission. We are acutely aware of the
essential role buildings play in carrying on the
enterprise of higher education. Each time a
building project is undertaken, the overall
impression of the campus is affected. The
superior teaching and good communication
that sustain a college or university are enhanced
by their environment. Building projects that
pay attention to the learning needs and changes
will continually rejuvenate the institution.

much the same way it would approach other communications projects. "We do not seek interactive work for its own sake, but feel it is an important aspect of our work in identity," says Hall. He explains that there are many facets to the development of a corporate identity. "The firm's involvement could include conceiving the name and a logo as well as all the ways in which the name and logo are seen and communicated. It could take anywhere from six months to five years to implement."

Hall observes that clients' priorities have changed when it comes to identity development. "In the past, we would normally start with a capabilities brochure as the first priority in establishing the identity. Today, more and more of our clients are asking for Web sites or interactive presentations before talking about a corporate brochure," he relates. "This is especially true with our clients that are in the technology industry. The Web is more appropriate and faster in its delivery of the identity."

Hall strongly believes that it's hard to separate a design concept from the medium one is

(Above and right) Allina Interactive Sales Presentation
Allina Health System, a large health care and health insurance system, wanted a way for member physicians and their staff to quickly find information on preventive health care. This interactive CD-ROM sorts the information by patient age group and prevention types. Within a given section, the user can select the hammer icon to pull up information that can be printed out and given to patients or used by staff. Clicking on the icon opens the tool window which partially covers the old window. By setting the tools in their own window, the user can use them without losing their place within the broader program. Accompanying print manuals were designed using the same graphic iconography and color palette.
Designer: *Michael Hall*

working with. As a result, he has taught himself a basic understanding of Macromind Director. "I will use it as a sketch pad for interactive ideas," he states. "Even though I don't do much of the technical work, I think it is important that I can talk with the people who are actually doing it."

Because they consider new media just one aspect of their identity work, Hall Kelley has elected not to hire codewriters and developers. "We specialize in identity," explains Kelley.

ALLINA PREVENTION NAVIGATOR

Introduction Navigator Tools Immunization

Tips

1

Keep current by reading trade journals, learning from technology support specialists and experimenting with new technology and software.

2

Find good people or firms who specialize in areas and services that you don't want to provide in-house.

3

Have a plan before you begin.

4

Create a structure diagram for your interactive projects. Keep looking at the big picture as you work out the details.

5

Learn from viewing interactive presentations on CD-ROM. We have found designing for the Web limiting and have noticed that CD-ROM design can be a good preview of what the Web will be capable of handling in the future.

"We will never specialize in electronic media. We always have to be aware of being able to use new media, but we are not a multimedia company. It's not our focus, it's just one tool in a whole array of communications tools that we'll provide the client." Hall Kelley also wants to maintain a small staff. "We've had the company at various sizes over the sixteen years we've been in business—but we make an effort to keep our company small," says Hall.

To accomplish the technical aspects of new media projects, Hall Kelley has developed partnerships with companies and individuals. "We've usually connected with these people through referrals," says Kelley. "Or we might run into a developer or programmer who is working with one of our clients on a mutual project and we connect that way." Kelley also recommends checking professional business and design directories to find development support services. "However, I've found word-of-mouth referrals to work the best," she relates.

When selecting the company or individual to partner with, Kelley says she seeks a technician with a complete knowledge of the field and a creative mind. "When looking for programming assistants, one of the things we are interested in is that they know standard HTML and have those kinds of skills, but that they're also interested in trying to accomplish things that others can't." She cites a situation where it was necessary for their programmers to go the extra mile. "In addition to letterhead, one of the things we are doing as part of our identity work is electronic forms, so that on every employee's computer there is a standard tem-

plate for doing faxes, e-mail and memos," says Kelley. "We want these items to fit in with the family of printed materials that we've designed. We've found using the standard off-the-shelf programs too limiting, so we develop our own programming. Sometimes these types of projects can be harder to set up from a technical standpoint."

Although Hall Kelley has had to invest in new equipment and make adjustments in the way they do things, Kelley admits to having no qualms about moving into new media. "I guess it adds another layer of work and frustration, but I've just accepted that it's another way to communicate. I think new challenges are good," she explains. "Coming from a communications background, I am used to using multiple communications vehicles. Michael, having a scientific background, is a person who likes to try new things. When you've worked in communications for twenty years, it gets tiring doing the same thing all the time."

Hall is more circumspect in his assessment of new media. "It is always stimulating to learn new things," he says. "But I find it both exhilarating and troubling to be living in the middle of a technological revolution. The more I see images and words on a computer screen, the more I appreciate books, paper and ink on paper." Hall is also bothered by new media's transience. "Another conflict I have with new media involves my instinct as a designer to make things. I get satisfaction from creating something you can touch, something that doesn't disappear when the electricity goes out."

case

study 14

THE

DUPUIS

GROUP

Glendale

Always interested in drawing and animation, Steven DuPuis began his design career while in college at Long Beach State University in California. "During school and after graduation, I was working as a swimming pool designer, which was a great job to have in the early 1980s," he recalls. "Looking back on it, I learned a tremendous amount in school and on the job. Designing hundreds of shapes for people's backyards helped enhance my layout abilities, which is why I never underestimate a job or its value no matter how trivial it may seem."

After three years designing pools, DuPuis started to become restless. "I did not want to be in the pool business for the rest of my life," he states. The decision to leave came in 1986, when DuPuis started a home-based design business. "The advent of the computer had a large impact on my decision to open my business," says DuPuis. "I had been trying for years to find some point of difference to set up shop and this new technology was just the ticket." DuPuis' first clients were former pool clients. Satisfied with his design ability (they saw it everyday in their yards), they brought branding,

> Clients don't want a jack-of-all-trades. If your goal is to be a Web design firm, then structure your firm accordingly.
> —Steven DuPuis

packaging and collateral design work to DuPuis.

"It was in 1991 that we were first introduced to what at that time could be called 'new media,' and that was through a program for the computer called Macromedia Director," recalls Steven DuPuis. "We saw the opportunity to place our entire portfolio on disk for promotional purposes. We went to work creating it and producing packaging that would hold the disk."

The venture proved to be well worth the effort. Perceived as being forward-thinking and creative, DuPuis and his designers landed new clients such as Guess? and Diamondback Bikes, while their interactive presentation caught the attention of industry colleagues in *HOW* and *MacWeek* magazines.

Although it sounded like the start of an exciting and profitable area of new business, it was not to be. "Unfortunately, the energy produced by our interactive work was diffused as the com-

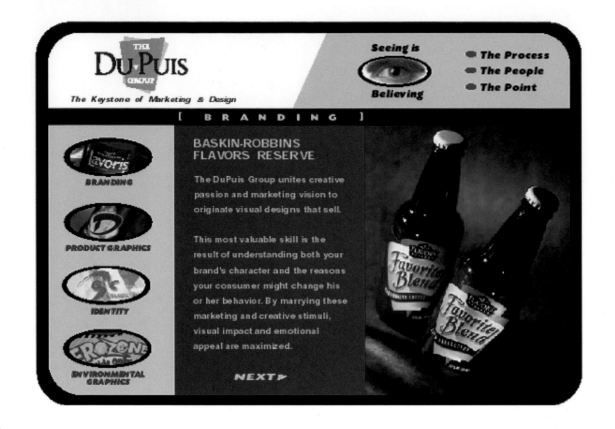

pany began to take on more partners," says DuPuis. "This eventually culminated with the merging of our company with a larger one. At the time I thought it was a good move because of the cost of technology, but it proved to be disastrous. The merger only stifled our progress and growth as a firm." Feeling that he had not achieved his goals as a designer and entre-prenuer, DuPuis resigned from the corporation.

DuPuis found a new partner, Donald Esters, a former CEO of a large corporation and owner of EIS, a communications technology company. Seeing the potential of their combined exper-tise, the two formed the DuPuis Group. "This was a great fit, because it allowed us to stay in touch with new technology," says DuPuis.

Since their partnership two and one-half years ago, DuPuis and Esters have grounded their firm on strong marketing principles and a business philosophy that places limitations on the firm's involvement in new media. "I have been very careful, because I have seen several of my col-

leagues set up shops exclusively for Web and CD-ROM design only to find these projects are not financially successful," explains DuPuis. "The value that the business community has placed on new media has not been enough to support professional design teams, although the trend is starting to shift as the medium grows into its own."

The DuPuis Group is a thirty-person design company that looks for long-term client rela-

tionships. "Our clients look to us for more than design services," says DuPuis. "We're stewards of their brands. We create new brands or revitalize established brands. We plan and oversee all creative efforts pertaining to the brand." says DuPuis. In this capacity, the

www.digitalammo.com
The Digital Ammo Web site offers a quick tour of a variety of creative styles. The site emphasizes the firm's ability to hit target audiences with greater accuracy
Designer: *Tim Schmidt*

Tips

1

Stick with what your firm does best. Don't try to be a jack-of-all-trades.

2

Be cautious when transitioning your firm from print into new media projects.

3

Before getting involved in new media, know your market and determine if there's a need for new media in your area.

4

If you see a need for a new media application for an existing client, promote concepts that add value to that client in a unique way.

5

If you take on a new media project for the first time, don't try to do it all in-house. Contract with new media firms or individuals who can provide this expertise.

DuPuis Group is in charge of the brand's appearance in all media, including new media. "You need to think about new media from the beginning and how the brand is going to look on a Web page," he explains. "Even a brochure design raises questions. Is this going to go on the Web and, if so, how should it be translated?

Because the DuPuis Group has elected to focus primarily on marketing and design specific to branding, the firm has formed many strategic alliances in the production of its clients' new media projects. "We handle all print in-house,

but in areas such as video, Web and other new media forms, we have set up partnerships with companies that we believe share the same approach to creative excellence," says DuPuis.

One such alliance was recently created with a former employee, Tim Schmidt, who left the DuPuis Group and started a Web development company called Digital Ammo. DuPuis considered incorporating Digital Ammo as part of his firm, but ultimately rejected this concept. "We see ourselves as brand experts and directing the implementation of these brands in different disciplines," he states. "Digital Ammo is totally focused on new media disciplines, which requires different staff and equipment."

Instead, members of the DuPuis Group join forces with Digital Ammo on new media projects. "We work as a team," says DuPuis. "We often have brainstorming meetings which include all team members from both companies." Once the navigation and content are established for a site, Digital Ammo programs and puts the site together. Creative review boards, comprised of both firms, check to see

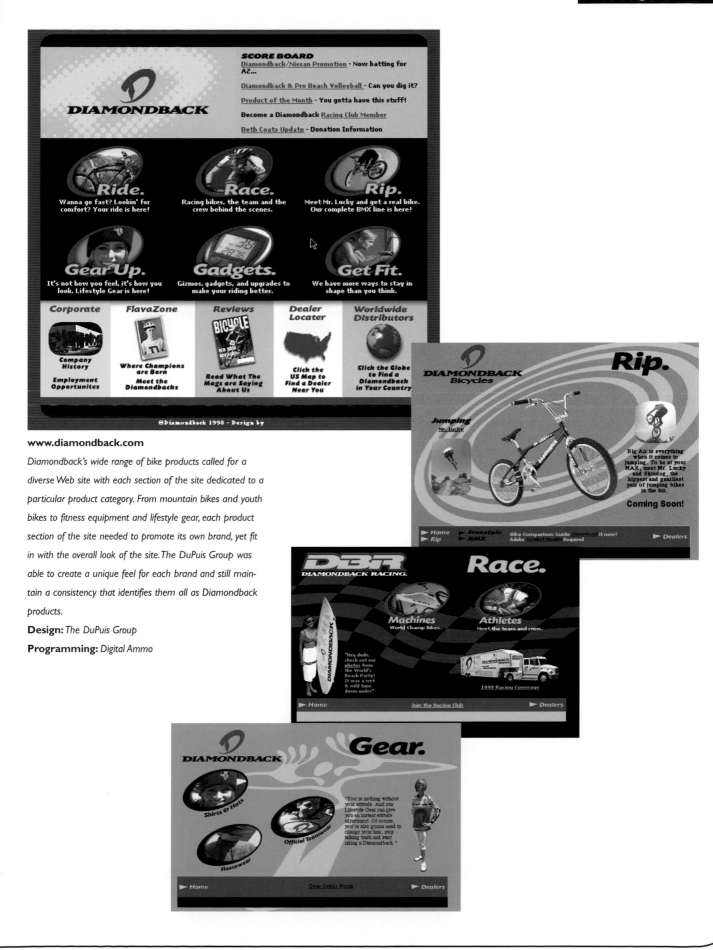

www.diamondback.com

Diamondback's wide range of bike products called for a diverse Web site with each section of the site dedicated to a particular product category. From mountain bikes and youth bikes to fitness equipment and lifestyle gear, each product section of the site needed to promote its own brand, yet fit in with the overall look of the site. The DuPuis Group was able to create a unique feel for each brand and still maintain a consistency that identifies them all as Diamondback products.

Design: *The DuPuis Group*

Programming: *Digital Ammo*

Diamondback's brand identity is centered on a flowing graphic D. In addition to logo designs that work with the Diamondback logo, the DuPuis Group's development of brand identities for Diamondback's various products include extensive color explorations and specifications for where to place the logo on each bike model.

Creative director: *Steven DuPuis*

Marketing: *Joe Greenberg*

Designers: *Tim Schmidt, John Silva*

that the project is on track. When the site is completed, Digital Ammo hosts and maintains it.

DuPuis recommends that design firms be cautious when pursuing new media work. "Assess your strengths and how you are perceived by your clients," he states. DuPuis believes that design firms should specialize in their area of expertise. "Clients don't want a jack-of-all-trades. If your goal is to be a Web design firm, then structure your firm accordingly." At the beginning, DuPuis even recommends doing new media jobs as a separate venture. "It might be better to freelance for a time until you see the volume of jobs to determine when to bring it in-house."

www.bikeshow.com

Southern California Bicycle Expo is the country's largest consumer bike show. With a high percentage of cycling enthusiasts online, this site needed to do more than just offer show information. It offers product reviews, racing news and fun cycling games and contests.

Design: *The DuPuis Group*

Programming: *Digital Ammo*

case study 15

OH BOY!, A DESIGN COMPANY

San Francisco

New media is an exciting addition to the long list of accomplishments of designer David Salanitro, founder and creative director of Oh Boy, A Design Company. Since starting his design career sixteen years ago, Salanitro has acquired expertise in the areas of architectural, exhibit, theatrical and graphic design.

Although he's at a point now where he can add new media to this list, things were different when Salanitro first got involved. "It was not a medium I liked or enjoyed," he states. "When the firm started doing Web sites in 1995, we simply didn't know enough about what we were doing," says Salanitro. "Since our first three Web sites, we've certainly learned much more about the medium."

Salanitro admits that for a long time he didn't feel the firm's Web work was on a par with its print work. Oh Boy initially got involved in new media by producing a Web site to go with print collateral they had designed for a long-time client. "I actually thought it was quite nice," recalls Salanitro, "It was simple and clean, but

> I constantly remind my staff that, although the client may want to, we can't just put a brochure on a Web site. It's a totally different medium.
> —David Salanitro

the client didn't like it because it didn't have enough bells and whistles for them."

Since that first experience, Web projects at Oh Boy have yielded more positive results. However, Salanitro is quick to point out that Web design should support print and not vice versa. "We get many calls from clients who want to be able to integrate Web work with their print work," he says. "I constantly remind my staff that, although the client may want to, we can't just put a brochure on a Web site. It's a totally different medium."

At this time, Web site design is a small percentage of work at Oh Boy. "Our clients are generally looking to establish a presence through print collateral and electronic media," says Salanitro. "Because electronic media is so completely different from print, with its own unique set of production and communication problems,

Oh Boy Promotional Materials

The Oh Boy Guide client binders are used to promote the firm's work to prospective clients. They also house humorous pieces, such as the "5-to-9 Guide," things to do during the late night hours all year long.

Art director: *David Salanitro*

I believe it needs to be addressed as such. However, if a company has an identity or corporate standards manual, those standards should be applied to all communications—traditional and electronic."

Like all projects at Oh Boy, creating a Web site involves everyone. "Everybody's a designer to some extent," says Salanitro, referring to his staff of nine. "We don't have any production people per se. We have a production traffic manager, five designers and three administrators." After Salanitro and his staff have met with the client, they issue a creative brief based on their objectives. Within the brief, they determine if a Web site is the right

medium. "If we decide it is, the site development begins," says Salanitro.

Oh Boy will typically come up with a concept for the site as a collaborative effort, but each Web project is eventually assigned a designer to direct the work. As the work on a site progresses, the entire staff gets involved in critiquing it and suggesting refinements. "We have an area at Oh Boy that is completely isolated from any client traffic," says Salanitro. "This is where everything goes on the walls for comment. It works really well, because we go through many revisions before the client even sees it. We can evaluate the concept and navigational system to see if they meet the client's

www.ohboyco.com

The Oh Boy site's home page translates "Pulp" and "Guide" into Japanese kanji when they're selected. The "Pulp" button leads the viewer to an ongoing series of illustrations that tell the story of Oh Boy. Selecting the "Guide" button offers information about the firm's capabilities and allows users to view a portfolio of recent projects.

criteria." At this point Salanitro and his staff determine how to move the viewer around the site and where links should go. "When we are satisfied, we will present two unique navigations and concepts to the client," says Salanitro.

Developing content is another area that gets much attention from Salanitro. "I write content," he states. "I do it because I like it and I see it all so much as a whole—the copy and the design. And we try to make things really clear for the viewer."

One aspect of the presentation process that has proven difficult for Salanitro and Oh Boy is the lack of quality they've encountered when presenting a site prototype online. "Sometimes we don't even show screens, especially if it's for a client who hasn't done anything on the Web," he relates. "We'll show them an Illustra-

tor printout until they become more familiar with the Web and its limitations."

At this point in time, Oh Boy has elected not to bring a codewriter on board. "We have a programmer who we use exclusively on a consulting basis," says Salanitro. "This works for us now, because if we tried to attempt this ourselves, it would be twice as slow and cost six times as much." Oh Boy offers to hire the programmer for their client, "or we recommend that our client hire him and then we direct him," says Salanitro. "Because we don't pretend to have that knowledge, we purposely keep our consultant a separate entity."

Setting up a collaboration of this type takes care and trust. "They have to trust you and you have to trust them," says Salanitro. "Our programmer doesn't tell us how to design, and we don't presume to know how to pro-

*For technical information, the viewer can select the specs icon
for any job showcased in the portfolio section to learn about
design criteria, print process, inks and specifications, supplemental
services provided and awards for that job.*

Art director: *David Salanitro/Hunter Wimmer*
Designer: *Alice Chang*
Writer: *David Salanitro*
Photography: *Hunter Wimmer*
Web coder: *IOsphere*

gram. We tell them what has to happen, and they make it happen." Salanitro was fortunate to have found his consultant in his building, but he suggests networking to find that perfect technical partner.

Having started out in print, Salanitro and his staff have had to educate themselves on designing for new media. "We are all online frequently in order to stay current," he states. "There is also a book by David Siegel we've consulted that is just phenomenal called *Creating Killer Web Sites.* As far as I'm concerned, that's the only book you need. He gives you tricks on how to do different things. He's absolutely extraordinary."

Permissions

Directory of Creative Professionals

The Design Office, Inc.
T.D.O. Interactiv
1 Bridge St.
Irvington, NY 10533
(914) 591-5911
www.thedesignoffice.com
www.tdointeractiv.com

The Designory
211 E. Ocean Blvd., Suite 100
Long Beach, CA 90802
(310) 432-5707
www.designory.com

Duffy Design
901 Marquette Ave. S., Suite 3000
Minneapolis, MN 55402
(612) 321-2333
www.fallon.com
www.duffy.com

The DuPuis Group
21700 Oxnard St.
Woodland Hills, CA 91367
(818) 716-2613
www.dupuisgroup.com

Hall Kelley, Inc.
661 Nason Hill Rd.
Marine on Saint Croix, MN 55047
(612) 433-4610
www.hallkelley.com

Interactive Bureau
251 Park Ave. S.
Tenth Floor
New York, NY 10010
(212) 292-1900
www.iab.com

Katherine McCoy
1855 N. Halsted
Chicago, IL 60614
(312) 943-4351
www.mccoykj@aol.com

MSNBC
One Microsoft Way
Redmond, WA 98052-6399
(425) 882-8080
www.msnbc.com

Nerve, Inc.
1600 Sycamore St.
Cincinnati, OH 45210
(513) 241-4550

NetCrafters
700 W. Pete Rose Way, Suite 343
Cincinnati, OH 45203
(513) 721-INET
www.netcrafters.com

Oh Boy, A Design Company
49 Geary St., Suite 530
San Francisco, CA 94108
(415) 834-9063
www.ohboyco.com

Pinkhaus
2424 S. Dixie Hwy., Suite 201
Miami, FL 33133
(305) 854-1000
www.pinkhaus.com

Sayles Graphic Design
308 Eighth St.
Des Moines, IA 50309
(515) 243-2922
www.saylesdesign.com

Segura, Inc.
1110 N. Milwaukee Ave.
First Floor
Chicago, IL 60622
(773) 862-5667
www.segura-inc.com

Time Warner
1271 Avenue of the Americas
Fifth Floor
New York, NY 10020
(212) 522-0697
www.pathfinder.com

Turkel Schwartz & Partners
2871 Oak Ave.
Miami, FL 33133
(305) 445-9111
www.tspmiami.com

USA Networks
1230 Avenue of the Americas
Third Floor
New York, NY 10020
(212) 408-8898
www.usanetwork.com

Zender + Associates
2311 Park Ave.
Cincinnati, OH 45206
(513) 961-1790